# SOUTHAMPTON

## THROUGH TIME

Jeffery Pain

AMBERLEY PUBLISHING

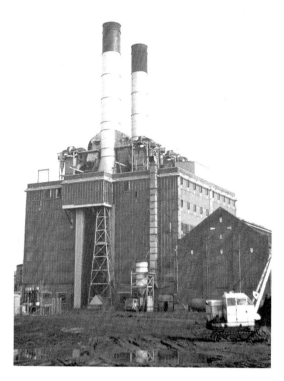

**Power Station *c.* 1970**
Seen here is the power station in Western
Esplanade in its last days in the 1970s. This
building was on the west side of the earlier
station (direct current only) of 1903, and
supplied alternating current, though parts of
the town were still on direct current until the
1960s. Now Toys-R-Us occupy part of the site.

First published 2010

Amberley Publishing Plc
Cirencester Road, Chalford,
Stroud, Gloucestershire, GL6 8PE

www.amberley-books.com

Copyright © Jeffery Pain, 2010

The right of Jeffery Pain to be identified as the
Author of this work has been asserted in accordance
with the Copyrights, Designs and Patents Act 1988.

ISBN 978 1 84868 808 7

British Library Cataloguing in Publication Data.
A catalogue record for this book is available from
the British Library.

Typeset in 9.5pt on 12pt Celeste.
Typesetting by Amberley Publishing.
Printed in the UK.

# Introduction

Southampton has a long history with some evidence of stone and bronze age settlements. However, in recorded time there was a Roman presence protected by a moat on the river Itchen called Clausentum. Later on, in Saxon times, a large trading centre named Hamwich was established on the west bank around the Northam area, and this in turn was replaced by an area on slightly higher ground on the river Test side by the tenth century, which became fully stone walled by the fourteenth century, being the basis of the modern town.

From the Norman to Tudor times, it was a thriving port with imports including wine and exports of wool. Later, after some two centuries of decline, its fortunes were revived with arrival of the railway from London in 1840 and the opening the docks in 1842. The docks have developed over the subsequent years with an emphasis in the twentieth century on passengers, which is maintained today by the presence of some of the largest cruise liners in the world.

An unlikely phase occurred in the late eighteenth century when for a while the town became a spa renowned for it's baths with health giving properties (allegedly). Around this time Jane Austen spent five years in the town, but she was not inspired to pen any novels during this period (presumably she was too busy enjoying the attractions of the spa).

So with the coming of the railway and the docks the town developed into the city of today, though with many trials and tribulations in times of war, financial problems and over labour disputes.

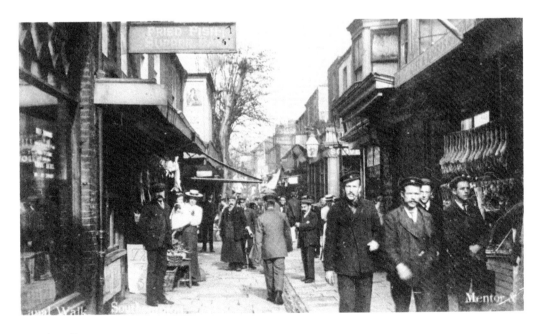

**Canal Walk** *c.* 1905
Canal Walk, colloquially known as the 'Ditches' (it was on the site of the town moat), was renowned for its many shops and the cheap offers on Saturday nights when many people would try to stock up with the luxuries of meat and fruit.

# Acknowledgements

I have endeavoured to group the illustrations on areas of the town albeit on a somewhat random basis with the general idea of showing what a difference the motorcar has made to the roads many of us use every day.

The 'then' pictures are all in my collection mainly, old postcards some 100 years old. However, there are two photos that I must credit: page 5 to Tony Chilcott and page 65 to the National Archives, Swindon. I apologise if any other credits have been omitted.

Also I must thank Mary, my wife, for doing the typing, carrying the camera bag and putting up with the chaos at home I have caused during preparation of this book.

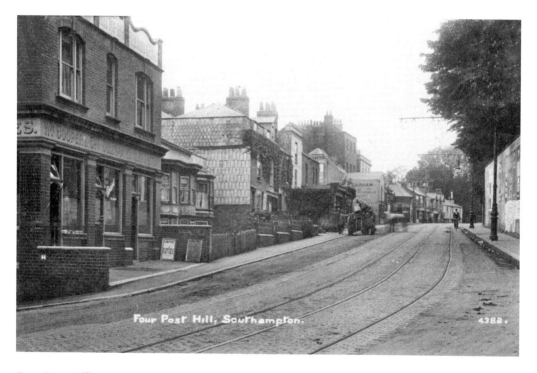

**Four Posts Hill** *c.* 1910

Looking west from Hill Lane the view today has changed and is now almost deceptively rural. Of the buildings on the left, those at the top of the hill were demolished for the bridge over the railway, some were bombed, and the remainder, including the Hill Top Inn, removed in the 1970s to allow redevelopment, road widening, traffic lights for Hill Lane, and a roundabout for the bridge.

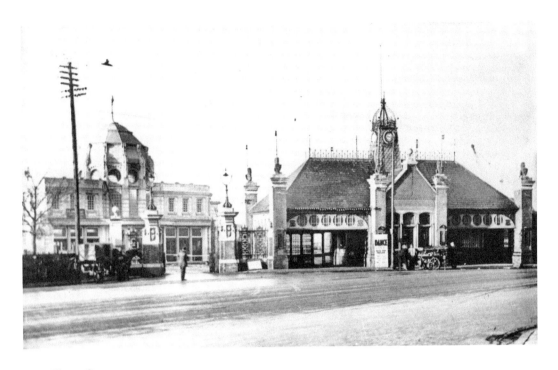

**Town Quay c. 1930**

Dated 26 November 1929, the above view shows the new third entrance building some way to the rear of the second (1892) building, made possible by reclamation of some 150 metres of foreshore for Mayflower Park associated with the building of the Western Docks 1928-1933.

The lions with their shields will be transferred to the new building, though without the flags and poles. The gateposts are also still in evidence but a little further apart and obviously without gates.

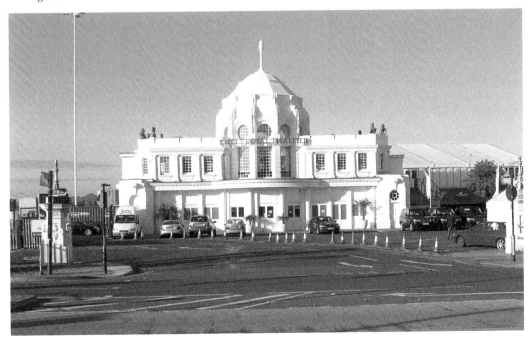

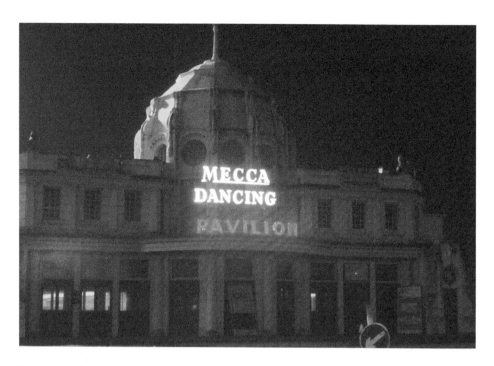

Town Quay *c.* 1972

Sometime *c.* 1900 the bandstand on the pier, which at this time was owned by the Southampton Harbour Board, was developed to include a theatre/ballroom. When this was taken over by the Dock Company they decided running of the pier was not part of their core business and Mecca leased the pavilion and restaurant; unfortunately, ballroom dancing was in decline and Mecca left. The pier remained open for pedestrians though with increasingly restricted space as areas became unsafe, and it finally closed 2 January 1980. After several attempts to use the listed entrance building, it has, with extensions on the south side, become an apparently successful restaurant.

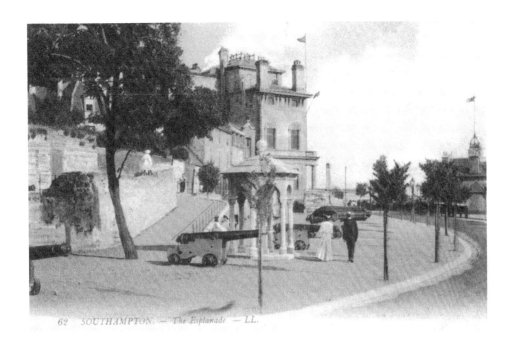

62 SOUTHAMPTON. — The Esplanade — LL.

**Town Quay** *c.* 1903
This scene is easily recognisable with the Stella Memorial, which commemorates the bravery of Mrs Ann Rodgers, a stewardess on the SS *Stella* who gave up her own lifebelt to a passenger when the vessel was wrecked on the Casquets Rocks near Guernsey 30 March 1899. The monument was paid for by public subscription and unveiled by Lady Emma Crichton on 27 July 1901.

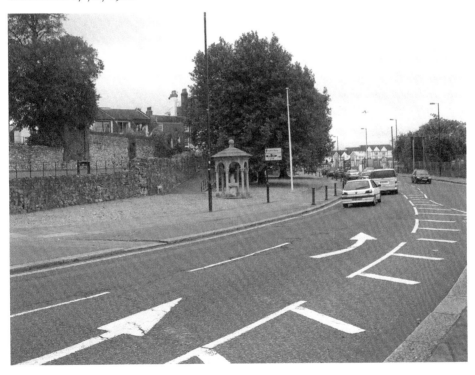

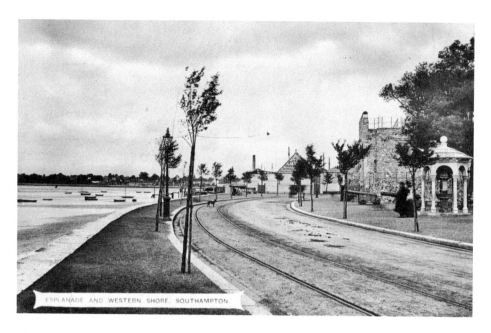

ESPLANADE AND WESTERN SHORE, SOUTHAMPTON

## Town Quay *c.* 1906

Looking the other way, with the Stella Memorial on the right, the view is much altered, with all the visible area being reclaimed as part of the dock extension in 1927/33. The railway track in the road was installed *c.* 1905 to convey material from excavations extending the original docks and was used to reclaim an area for Pirelli's cable works now replaced by West Quay shopping complex. In the current view one can see the Holiday Inn, left, and the De Vere Grand Harbour Hotel, right, and in the centre distance the yellow and blue of Ikea.

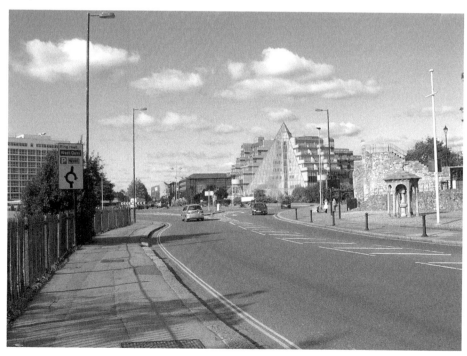

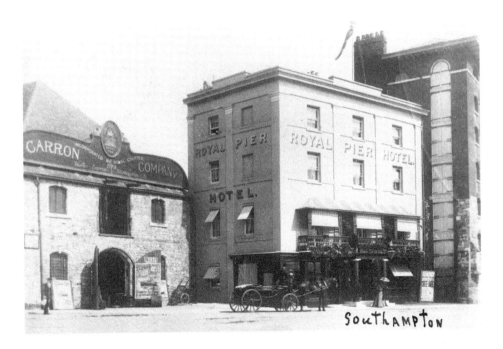

**Town Quay c. 1905**

The left hand building the Wool House still stands. Currently housing the city's Maritime Museum, it has had multiple uses over the years, being first a wool store, then a prison for French prisoners, then a store for the Carron Shipping Company, and later an aircraft factory, and a flour and food store. The other buildings, a hotel and a quayside warehouse, were destroyed during the Second World War.

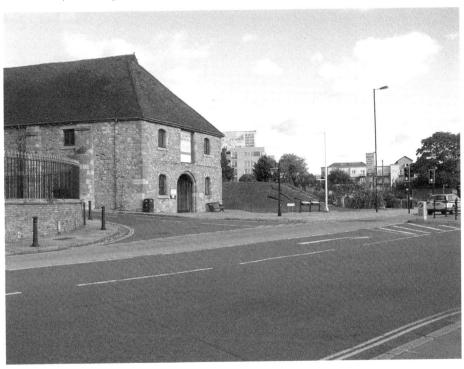

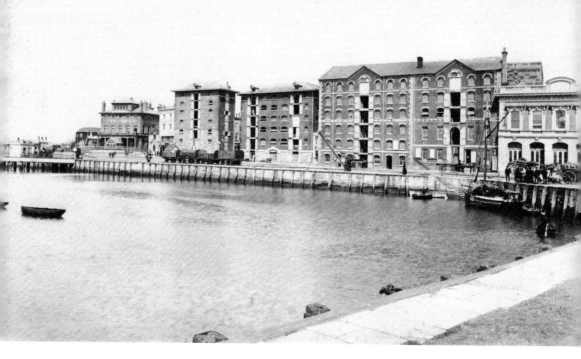

Town Quay c. 1885
Owing to new buildings, the angle is slightly altered. Looking at the original, the first pier entrance (single story) is on the extreme left, followed by the Yacht Club, and just visible is the Wool House (destroyed during the war), the Royal Pier Hotel, and two warehouse blocks. Finally, you can see another warehouse, which is now a restaurant and flats; an attractive building, which at one time served as the Custom House; and shipping offices, which is currently a Tapas restaurant.

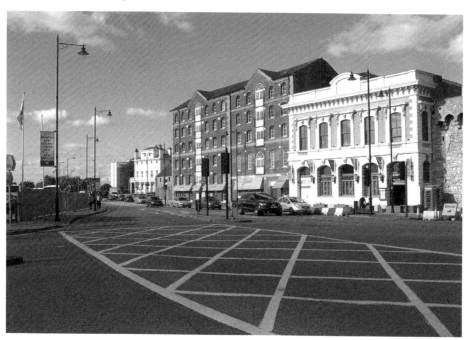

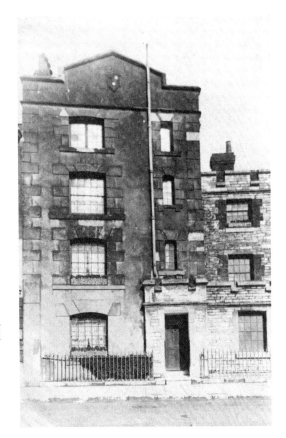

**Platform House *c.* 1905**
Platform House an imposing — if
rather dark — stone-faced building,
which apparently remained as a
private dwelling during the inter-
war period. Suffering bomb damage,
Platform House lost its top floor and
stone facings, though the door way
remains relatively unscathed. The
house has since been reconstructed
with a shop front, and nowadays it
is part of the Archaeology Museum
based in God's House Tower.

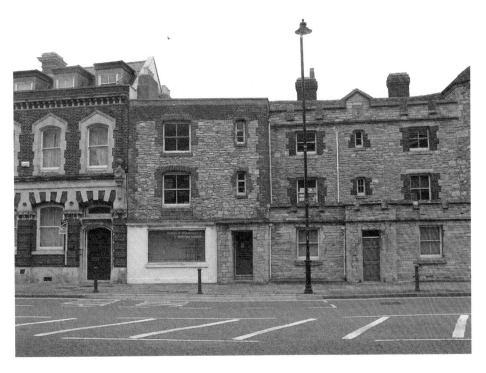

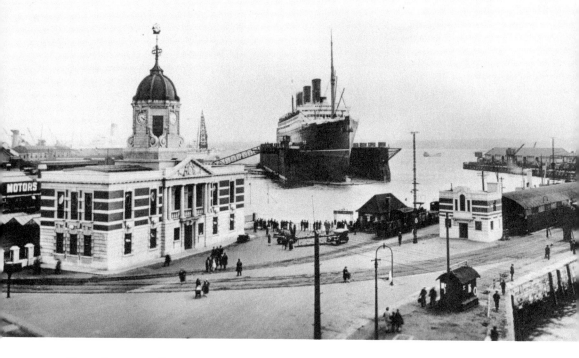

**Town Quay** *c.* 1928

On the left are the newly built Harbour Board offices, and centre stage is the floating dry dock, with the *Berengaria* out of the water. To the right is the town quay. Also note the area available to the public who could view the world's largest vessels high and dry. The dry dock was sold to the navy and went to Portsmouth in 1940. The Harbour Board is long gone and the building is now a casino. The town quay has been converted into restaurants, offices and flats, and is now used by some ferry services.

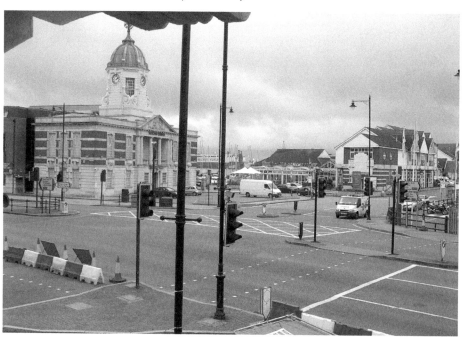

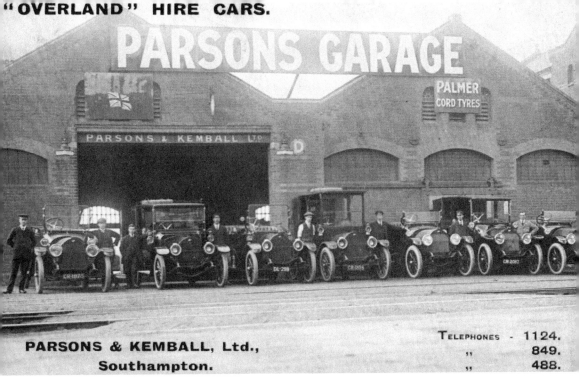

**Town Quay** *c. 1913*

What a marvellous line up of American-built cars for hire or sale, three of which show the Southampton CR registration, three that are unmarked and one interloper DL from the Isle of Wight. The cars are all of 'Overland' (Willys-Overland) manufacture, at this stage the second largest (after Ford) car manufacturer in the USA. Also note in the variety of body styles, one for every occasion. Parsons closed in the 1960s leaving the 'now' view rather uninspired.

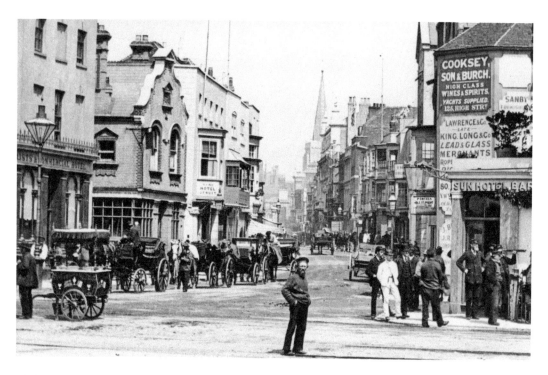

**High Street c. 1890**

A well-known view — but well worth reproducing — showing the bottom of the High Street. The detail and the people really catch the atmosphere of the time; note the handcart dispensing refreshments and the man on the right with a nautical-type cap and a telescope to his eye. Coming to the present, the only remaining building is Holy Rood church, which remains damaged and without its spire as a memorial to merchant seamen who lost their lives during the war. In the new view the old wall on the left was reconstructed from remains discovered when the obscuring buildings were blitzed.

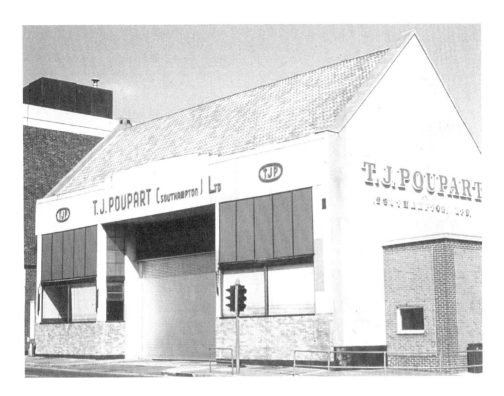

### High Street *c.* 1972

This was the site of the Hartley Buildings that housed the college, which eventually, after moving to a new site, became the University of Southampton. After the Second World War, Briton Street was extended from Canal Walk to the High Street, and a new warehouse for vegetable wholesalers T. J. Poupart was constructed. However, in recent years the site became available for redevelopment and these flats are the result.

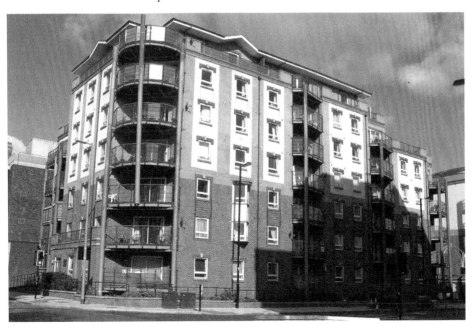

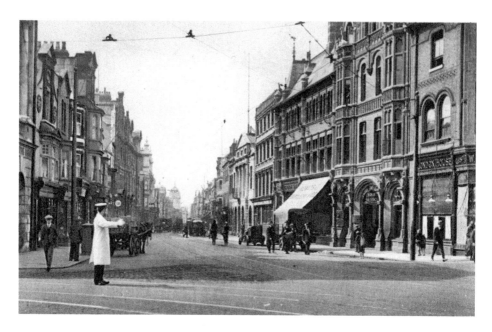

**High Street *c.* 1928**

Looking down the lower High Street from Holy Rood church with a policeman on point duty. On the right are some of the last late Victorian buildings in Southampton. The second building beyond was the Audit House, for many years the home of the civic offices before the Civic Centre was built, on the left the post office buildings remain but are now flats, and the Red Lion is still there. Otherwise, apart from ex-Harbour Board offices in the distance, bomb damage and redevelopement reign supreme.

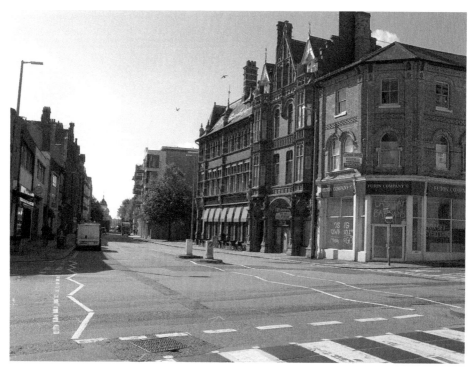

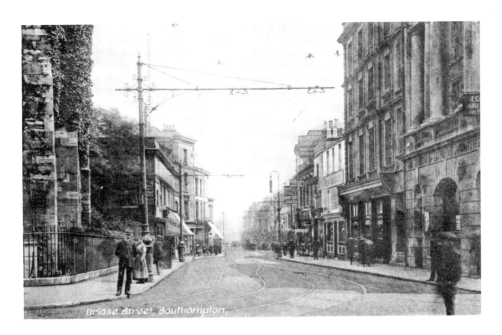

### Bernard Street c. 1903

Looking east from Holy Rood church along Bridge Street, now Bernard Street. Apart from Holy Rood church on the left nothing in view remains mainly through Second World War bomb damage. I do think that some of the old buildings were more attractive. Note the decoration work around the junction of the support poles and spans for the overhead tram wires, this design was unique to Southampton and is useful in identifying otherwise mystery pictures.

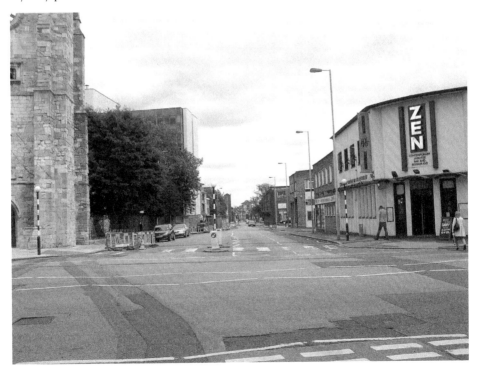

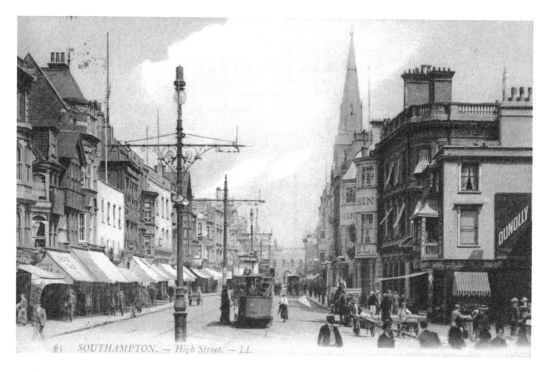

**High Street** *c.* 1905

Looking north from Holy Rood church, note again tracery on the support poles. The Dolphin Hotel and the building this side of it remain, but otherwise the majority were bombed or redeveloped. Even St Lawrence's church was redundant and demolished in 1927. On the left only the Midland Bank, which is visible in the distance, remains. The colouring on the tram is incorrect; it should be red not greenish.

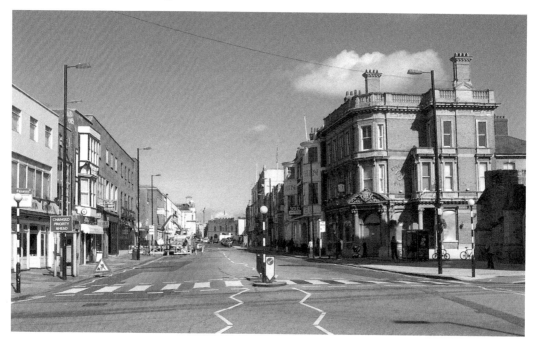

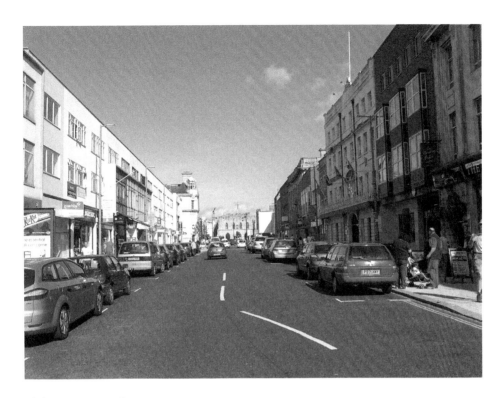

**High Street c. 1908**

Once again a scene changed by wartime. Remaining are the Star Hotel, right, the Bargate, middle distance, and also the Midland Bank, left. Just visible behind No. 30 is the front of St Lawrence's church. Not obvious but discernible is where the road narrows (by the clock) the tram tracks are interlaced, but this was replaced by a normal twin track a few years later.

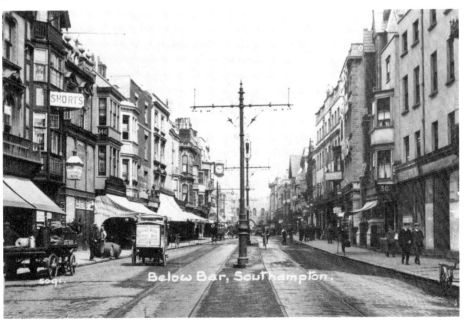

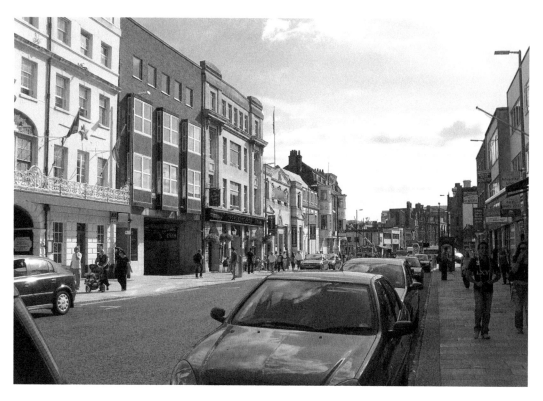

**High Street c. 1910**

Looking south, the ornate balcony of the Star Hotel is just visible and the entrance to St Lawrence's church, followed lower down by the Dolphin Hotel. Also in shot is the spire of Holy Rood church, with the post office building in the distance. On the right all has changed.

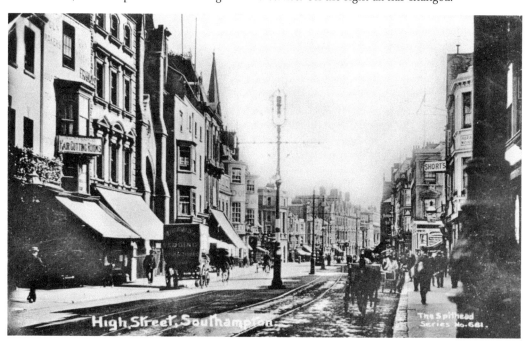

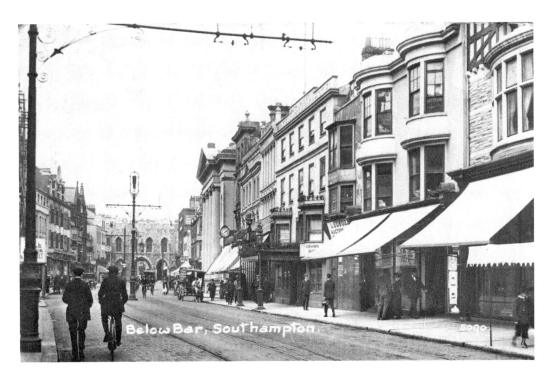

### High Street c. 1912

Looking north, the Bargate is prominent on the right. With its columns and pediment is All Saints church on the corner of East Street. A little nearer is the decorated front of the Crown Hotel. In the distance a tram is approaching the Bargate, and in the foreground the tram tracks are coming together.

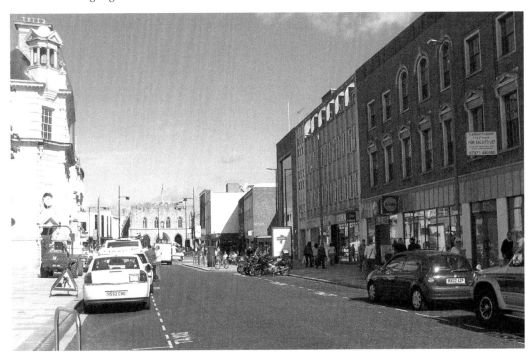

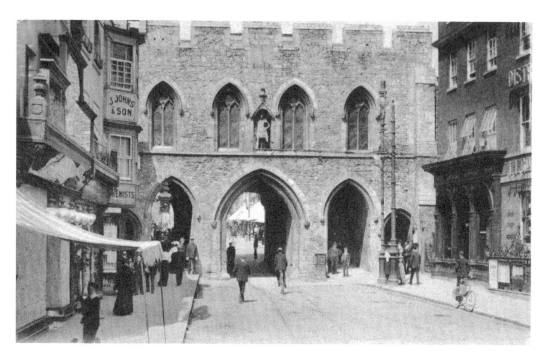

**High Street c. 1904**

The Bargate when all the traffic passed through the centre arch. At times it was busy with police on hand to control the traffic; looking through to the far side, right, one policeman stands in formal pose and next to the pedestrian arch, on the left, is the other. This particular card was produced in France where artists coloured a black and white print, hence the red brick tinting on the Bargate. Nowadays the entire area is pedestrianised.

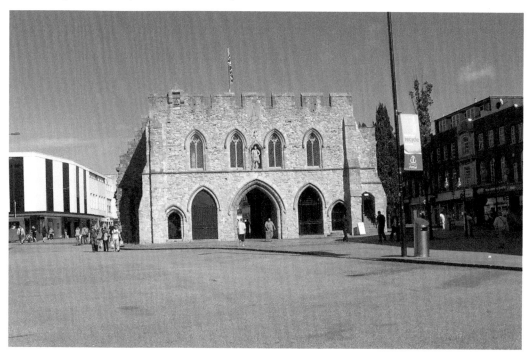

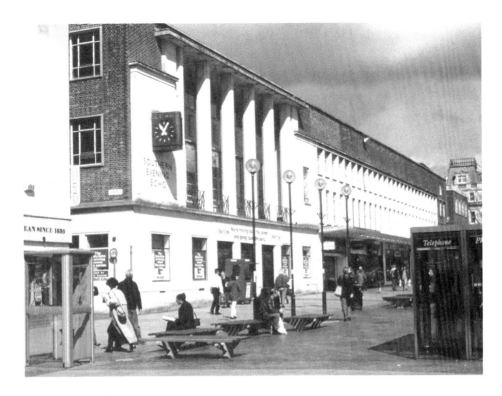

**Above Bar 1996**

Above Bar precinct and the imposing frontage of the *Southern Evening Echo* newspaper offices and printing works, who publish the local daily newspaper, dominate the scene; note the telephone kiosks, which are now becoming scarce. The works and offices have migrated to the edge of town to be replaced by the entrance to the West Quay shopping centre.

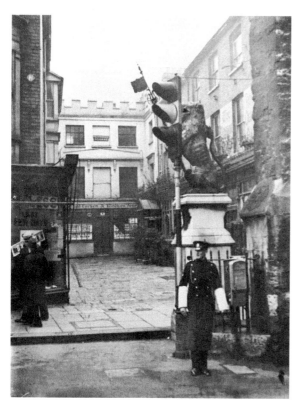

**Above Bar c. 1931**
Pembroke Square was a cul-de-sac on the north side of the Bargate, here about to be demolished to allow southbound traffic to by-pass the arch, but northbound traffic had to wait another five years. Note the policeman and the manually operated traffic lights that only required one officer on duty. The area is now pedestrianised, and the difference in the road level, which had been lowered to allow clearance for trams to pass through the Bargate, can be seen by comparing the height of the pedestal for the lions.

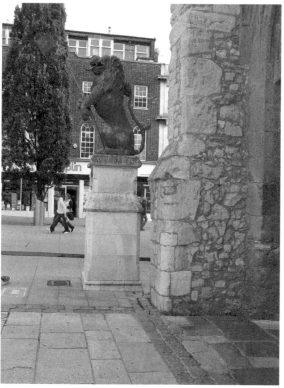

**Above Bar** *c.* 1972

The Odeon cinema was opened on 22 June 1932 by Captain Arthur H. Rostron with special guest Gracie Fields, it had seating for 1700 people and a Conacher organ played on the first night by Reginald Foort. It replaced a concert hall/cinema named the Alexandra. Originally named the Regent, it was renamed the Odeon in 1945. In 1979, it was converted into a two-screen cinema with 756 and 576 seats, in 1981 the restaurant closed to give another smaller screen. However, the High Street cinema days were coming to a close and it shut in September 1993. After redevelopment it became a Virgin store, but this having closed, the centre unit will now be a bank.

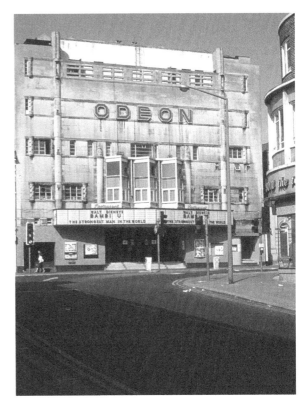

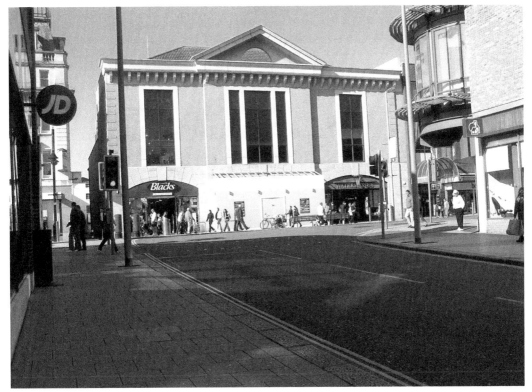

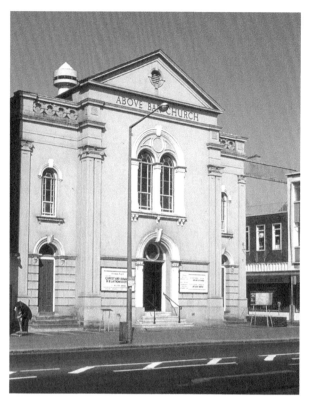

**Above Bar** *c.* 1972
Church of Christ, also known as Above Bar Church, now the Evangelical Free Church. The church was built in 1881 as a result of an American Evangelist Henry Earl who had preached next door in the Philharmonic Hall that had been on the Odeon site. It was demolished in 1979 and worship continues in an area over the shops on the ground floor.

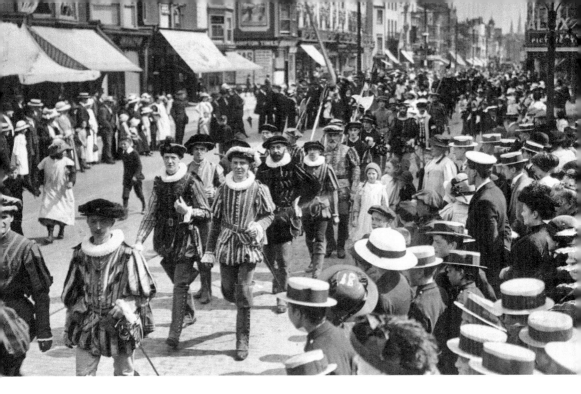

**Above Bar** *c.* 1914

This picture shows the Tudor Pageant of June 1914 passing through Above Bar, and on the left is Pound Tree Road — the Royal Hotel impressively centre of the picture. Above the Bargate are the spires of St Lawrence and Holy Rood. Looking at the 'now' picture, only the second building on the right and the Bargate remain. The pageant was to raise money to help pay for the spire of St Mary's church, which since completion of the main church in 1884 had remained without this feature.

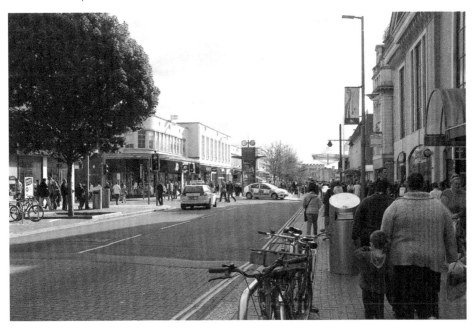

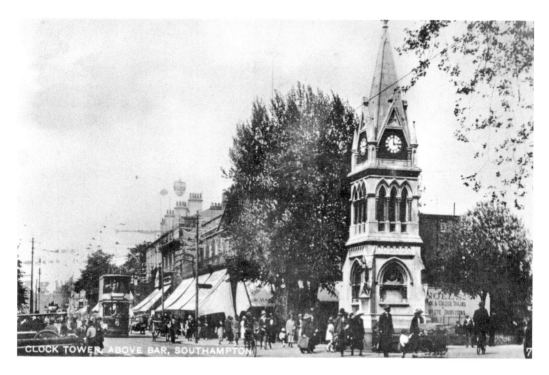

**Above Bar** *c.* 1920

New Road and the clock tower. This was a drinking fountain donated for 'both man and beast' by Mrs Henrietta Bellenden Sayers in 1889. By 1935, it was considered a traffic hazard and reinstalled on the Triangle at Bitterne Park. The square-topped covered tram will not be able to go through the Bargate but will turn left for Northam and pass behind the tower.

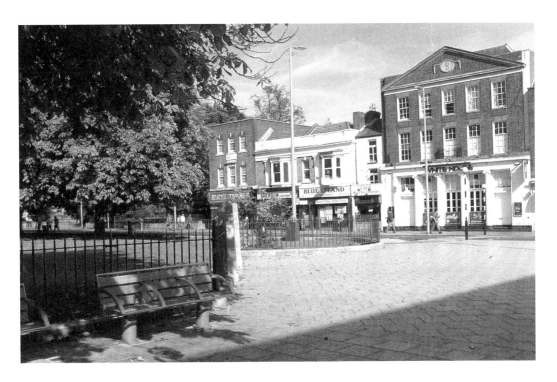

**Above Bar *c.* 1916**

The shelter at the Town Junction tramway, over the years it was rebuilt several times and from the early 1930s included a tramway control office and underground conveniences. Recently in some disrepair, it has been removed. I think this must be a Sunday as the old men look to be in their best clothes, and the soldiers appear to be in full kit but without rifles, perhaps taking a rest on their way to the docks.

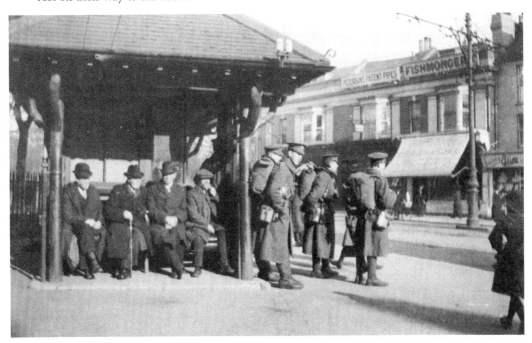

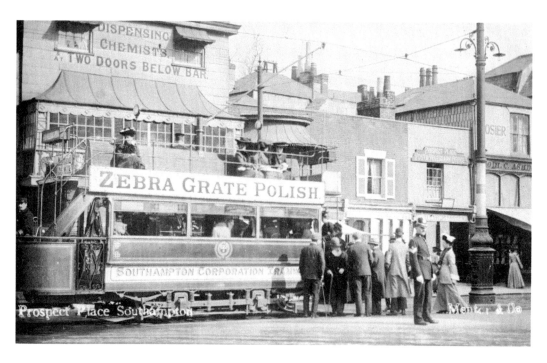

**Above Bar** *c.* 1904

A lovely scene with passengers boarding a northbound tram for Portswood. Note that the driver has no protection from the elements at this stage and ladies are happy to negotiate the narrow stairs to gain the upper deck with the 'zebra grate polish' modesty board, which hides their ankles from view. In the early days of electric trams red bands on a white base indicated tram stops.

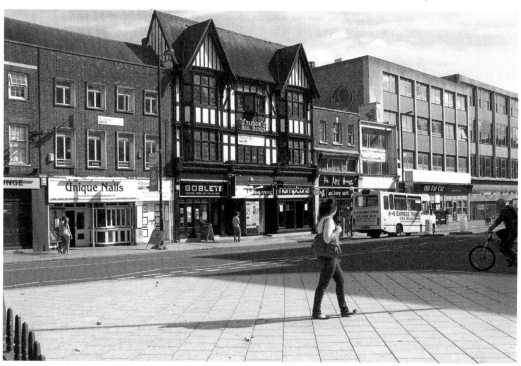

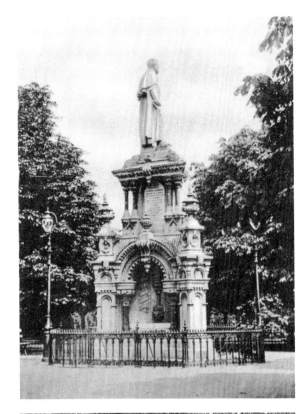

**East Park** *c.* 1905
The Richard Andrews memorial
is to a local businessman who was
mayor five times during his lifetime
(1796-1859). This ornate construction
included a drinking fountain, which
was paid for by public subscription
and unveiled in 1861. Unfortunately,
over recent years the stonework was
declared unsafe and removed. After
a while almost on the ground, he
has resumed some dignity on a new
cylindrical base.

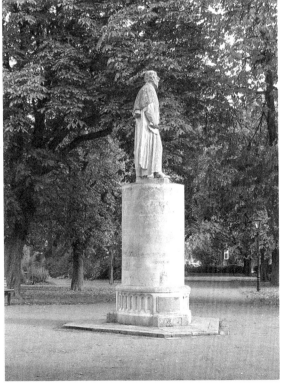

**Cumberland Place c. 1920**
A lovely row of upmarket Victorian houses, which over time were converted into offices; some development occurred before the Second World War but bomb damage encouraged new building, though some original buildings remain on the far right. Immediately on the right can be seen the public library, opened in 1893. Luckily it transferred to the then new Civic Centre in 1939, as this building was destroyed in 1940.

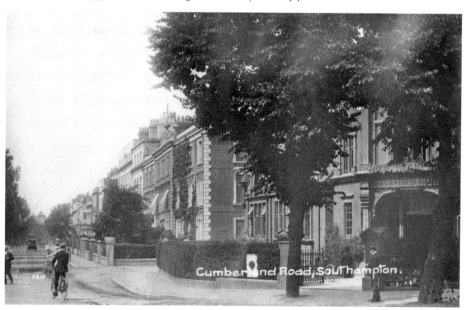

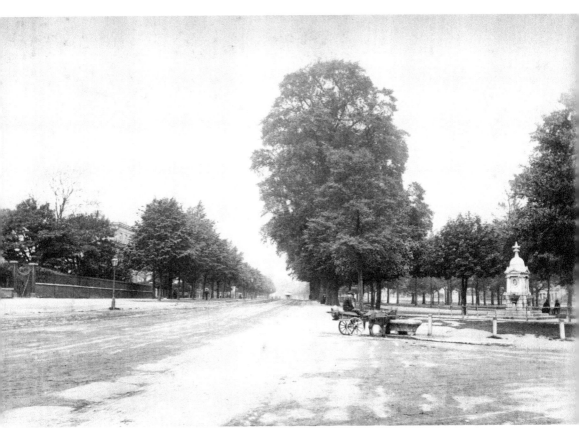

**The Avenue c. 1875**

The John Ransom fountain donated to the town by Councillor John Ransome (1779-1886), a local business man. Inaugurated in 1865 it was moved northwards to facilitate road works in 1966. Note in the original the horse trough servicing a pony and trap. This part of the tree-lined avenue is now part of a one-way traffic system around the park.

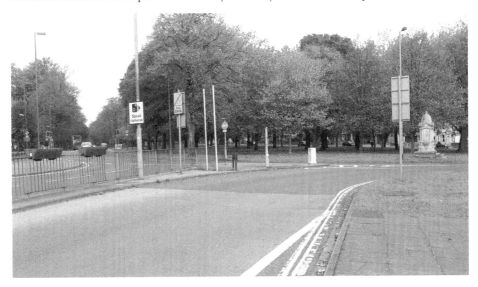

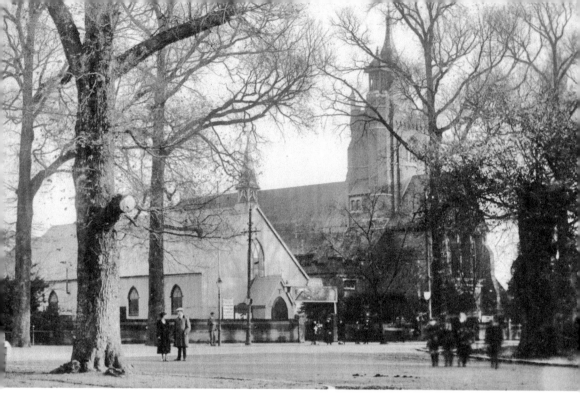

**The Avenue c. 1910**

Avenue Congregational church was built 1897-8 with its original church hall, which during the First World War offered succour to many of the soldiers camped on the nearby common before leaving via the docks for the trenches. However, apparently, winter refreshment is still available at the entrance to the common. Now a United Reform church, the hall has been rebuilt in recent years.

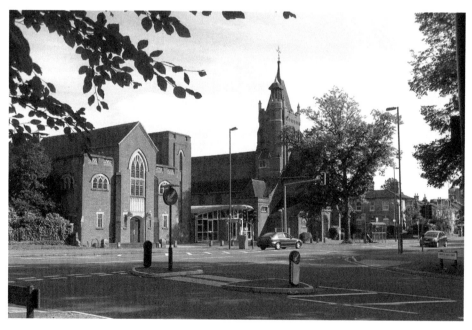

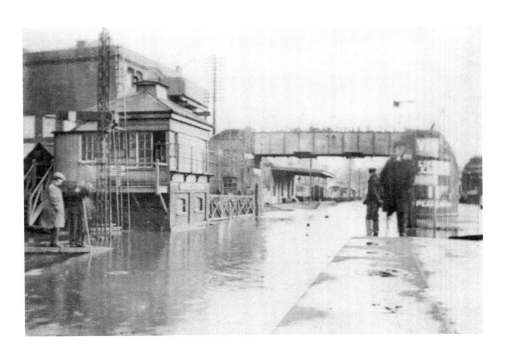

## Railway Station 24/11/1924

The 1892 layout at Southampton West under water, and this can still happen even now with the wrong weather conditions. Note the signal box with the level crossing gates — in use until the bridge over the western end of the station was opened in 1934/5. At the same time the station was enlarged to become Southampton Central. The footbridge is not part of the station but was for pedestrians to cross when the level crossing gates were shut. Visible under the bridge are remains of the original 'Blechynden' station.

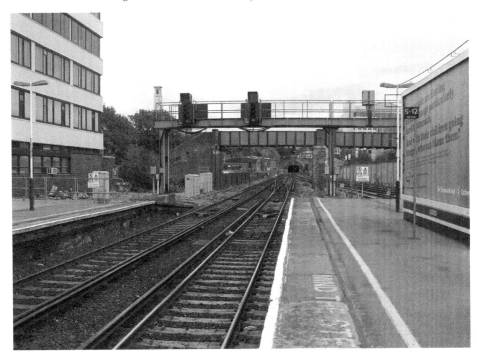

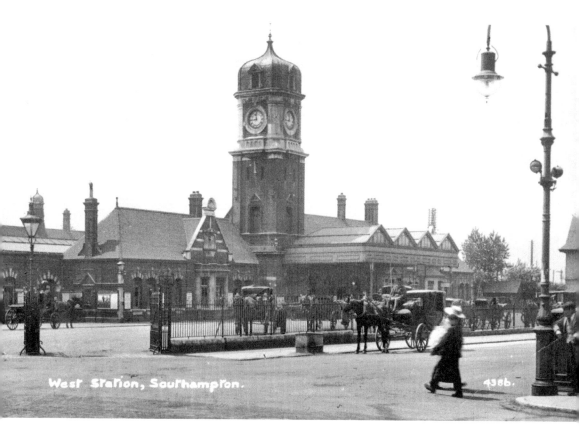

West Station, Southampton. 4386.

**Brook Road c. 1910**

The grand north (up) side forecourt and entrance of the 1892 station without a car in sight. Though bomb damaged during the Second World War, the main part, including the clock tower, survived until modernised in association with the electrification of services in 1967. The current entrance is just visible on the right with double white arrows on a red background.

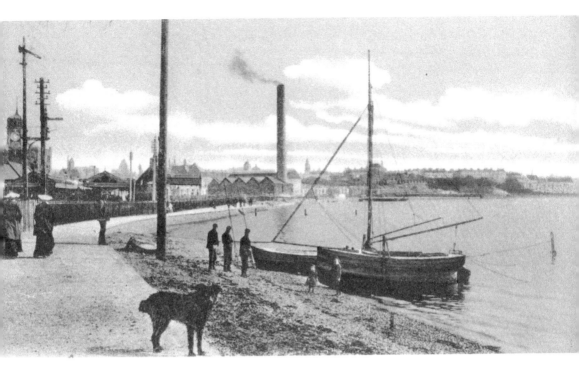

**Western Esplanade *c.* 1965**

Taken from the footbridge shown earlier, a royal train is about to pass through the station on its way to the Western Docks where the Queen with some of her family will board the royal yatch *Britannia* for their annual holiday in Scotland. Note changes to the buildings and a strangely empty car park (must be the weekend).

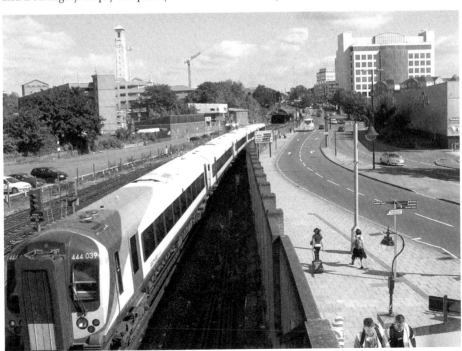

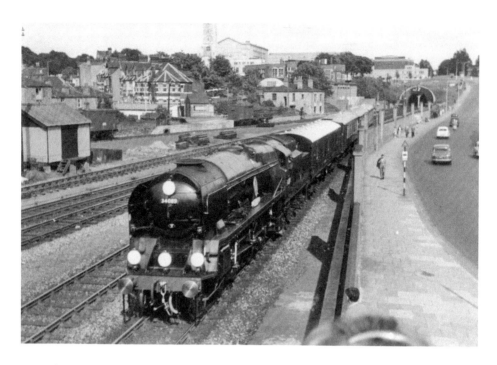

**Mountbatten Way** *c.* 1903

This is a view that requires some imagination. With a promenade on the foreshore (though not so attractive at low tide), the walk alongside the railway to Millbrook is still there but the sea is now some half a mile away. The tall chimney is the 1902 power station. In the modern view we have the down side car park (weekend again) with, on the other side of trees, Mountbatten Way, the new main road to the west.

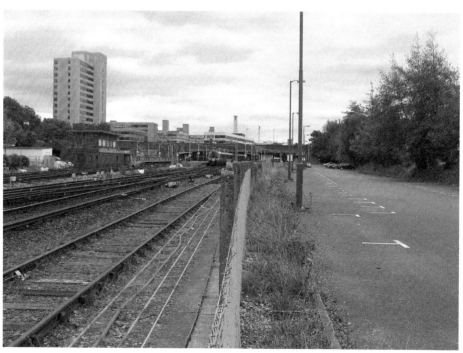

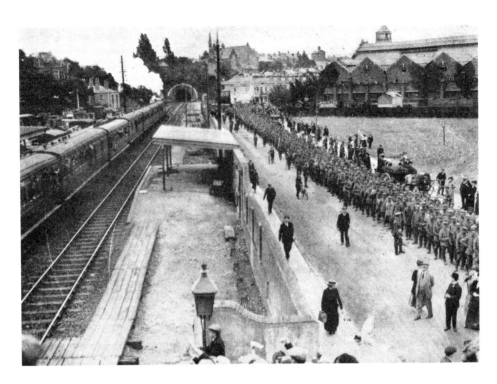

**Western Esplanade *c.* 1916**
The early picture is captioned 'German Prisoners', and shows prisoners captured at the first battle of the Somme awaiting transport to internment. On the right is the power station and in the centre the truncated remains of Blechendyn Station. The train about to enter the tunnel may be an earlier contingent of prisoners already on their way. At the top of the hill is a Congregational church, which later became a labour exchange until demolished for new road works in 1935.

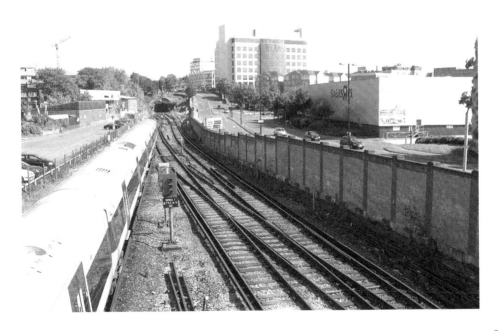

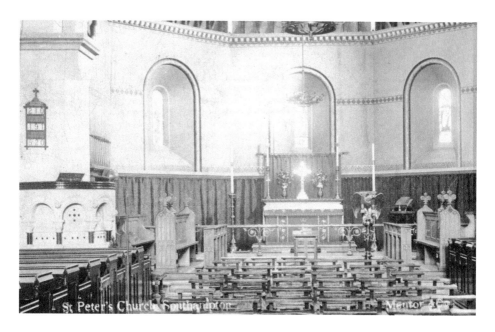

Commercial Road *c.* 1905

St Peter's church, which was built 1845-6, was designed by the architect Owen Browne-Carter in a neo-Norman style, with a distinctive tower having a four-gabled Rhenish top. However, it became redundant in 1979 and eventually it was altered to become a nightclub, Café Sol, and it is currently is a restaurant, Joe Daflos, which — all things considered — has a quite attractive ambience.

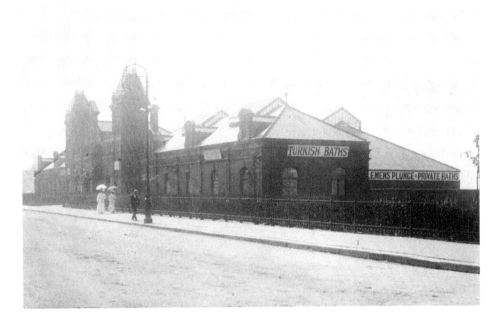

**Western Esplanade c. 1905**

The mid-Victorian seawater baths were then taken over by the corporation in 1890 and provided facilities for those without suitable home plumbing, though development, which included leisure, particularly with the lido at the back of the original buildings, greatly increased its usage. After the Second World War, popularity decreased and it closed in 1974. The new central baths, on the same road but lower down, facing the old town walls, only provided indoor pools.

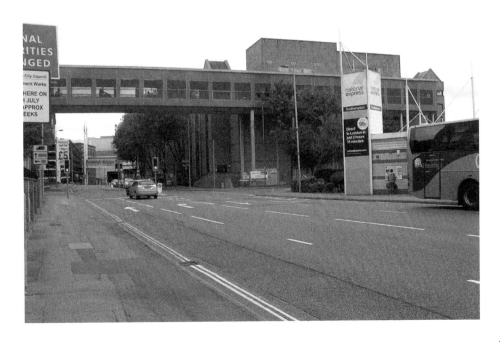

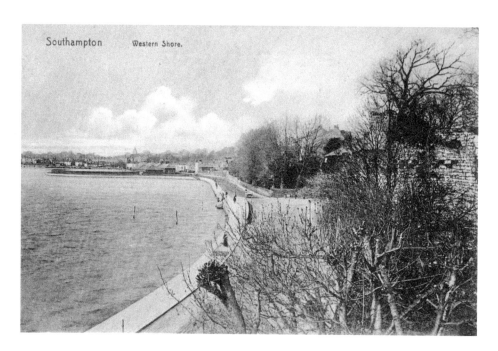

Southampton   Western Shore.

## Western Esplanade *c.* 1900

A lovely view at high tide with the water lapping at the town walls. In the middle distance can be seen the baths, with area behind about to welcome the electricity generating station, at this stage generating direct current only — alternating would come later, and the foreshore would disappear under Pirelli's cable factory. Now the trees have gone, giving a view of the walls, and so has everything else — in order to become the West Quay shopping centre.

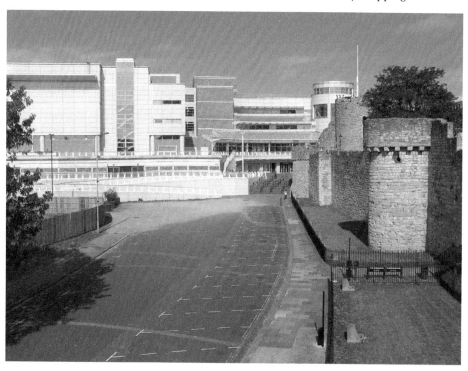

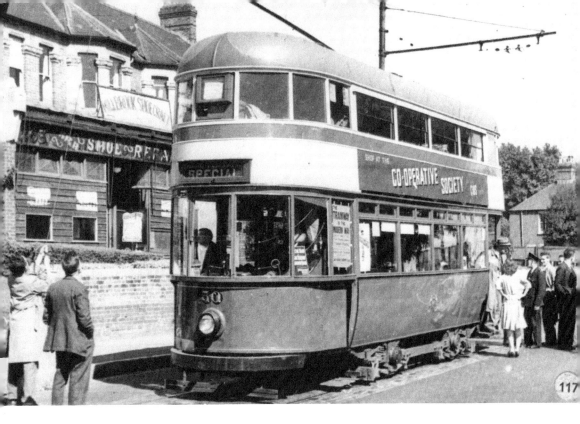

## Millbrook Road 1946

This view at Millbrook Tram terminus was taken on a special trip when the 'Light Railway Transport League' hired No. 50, the first tram repainted after the war for a tour of the system. This branch had closed to normal traffic in 1935 but was used for workman's cars until *c.* 1946. Note the shop front with partially boarded windows. This was quite common after blast damage as during the war replacement supplies of glass were problematic. The buildings remain, though the shop front has been bricked up.

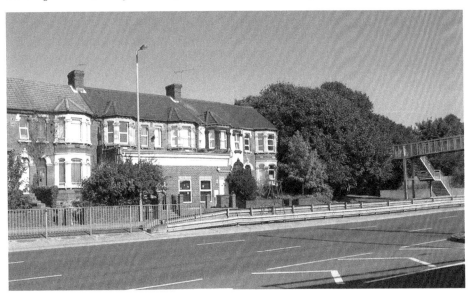

## Mountbatten Way c. 1905

Pictured is the beach at Millbrook with railway and station. Centre is a clutch of sites, including tidal baths, yacht and boat builder, and the ferry to Marchwood. Luckily it is possible to replicate the position from the new dual carriageway, which accesses the town centre on the reclaimed mudflats between the docks and the railway line. Note the area on the left, once a car parts factory but, like so much of the docks hinterland, now used as a car park or for container storage.

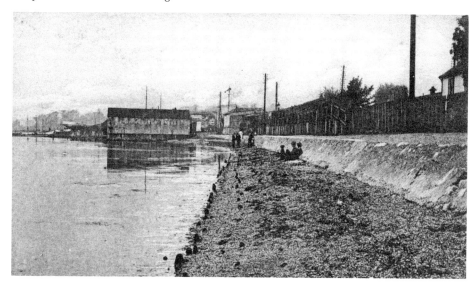

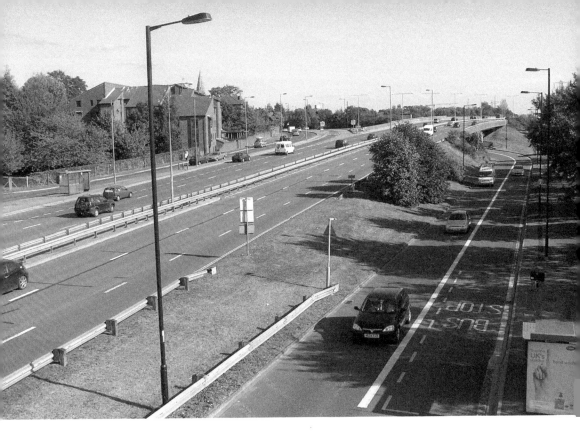

## Mountbatten Way 1905

Just slightly to the east of the previous view can be seen Millbrook Road, right, and Paynes Road, left, along which the trams ran. Note The Railway Hotel, renamed Maltster in the 1960s, closing in c. 1975, and demolished soon after. Beyond that can be seen an Oast House latterly belonging to Wm Cooper & Sons, which disappeared somewhat earlier. In the current view Paynes Road curves away centre left and the bus stop is on the site of the pub. Mountbatten Way is the new dual carriageway into the town centre crossing over the railway on the right.

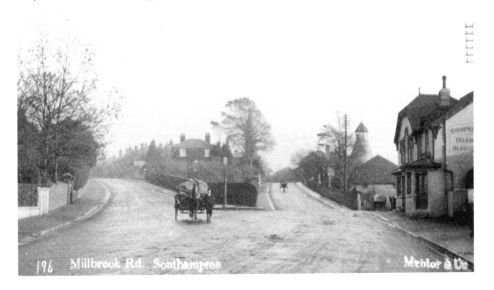

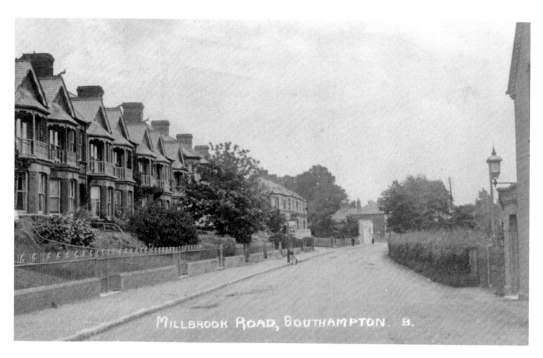

## Millbrook Road *c.* 1905

Some 200 metres further west but still looking east, this imposing terrace of houses remain but are now a rather motley collection having lost their first-floor balconies on top of the ground-floor bay windows. Not only that but for residents the view of the river Test estuary has also gone.

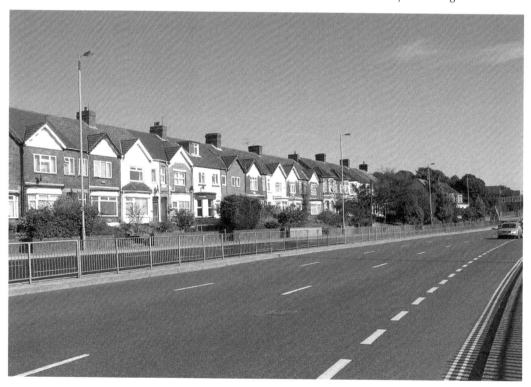

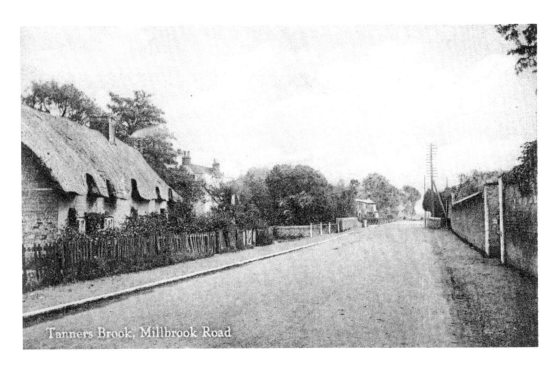

Tanners Brook, Millbrook Road

## Millbrook Road *c.* 1905

This view at the time was outside the borough boundary, which was Tanners Brook, this being marked by the bridge walls in the middle distance. Nowadays, with the six-lane dual carriageway, it is difficult to spot, but in the centre of the picture to the right of the trees is a white platform bed truck and a roadworks sign, and the brick wall alongside marks Tanners Brook. From this point it is piped under industrial units and the docks until it reaches the river.

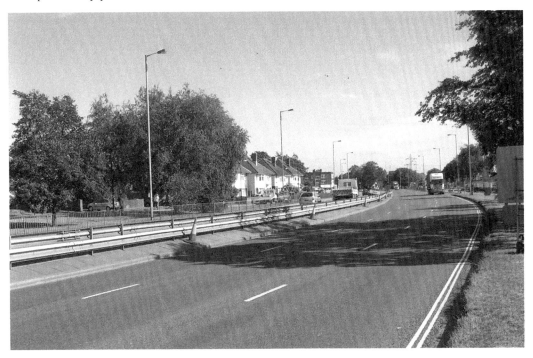

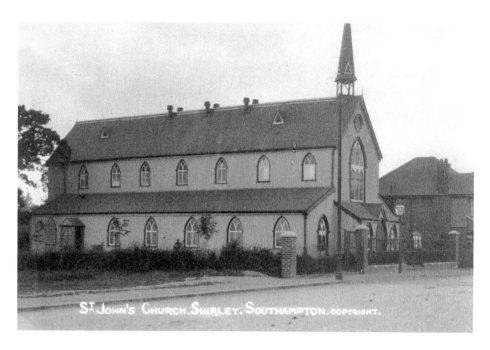

St John's Church Shirley, Southampton. Copyright.

**St James Road *c.* 1913**

Known as St John's Iron Church and erected in 1912, it was intended to serve a growing local population as a subsidiary to St James' church further up the road. The modern building, which was erected in 1960, is to my mind quite attractive but rather spoilt with an annex added and also, of course, modern clutter, a bus stop, a telephone box, cars and waste bins.

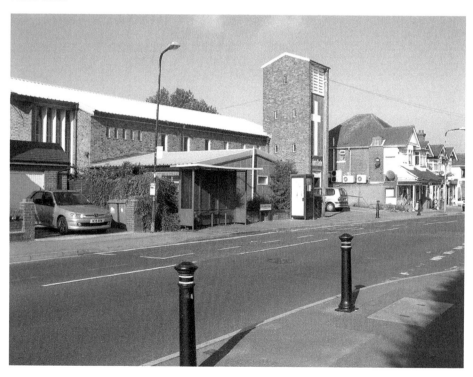

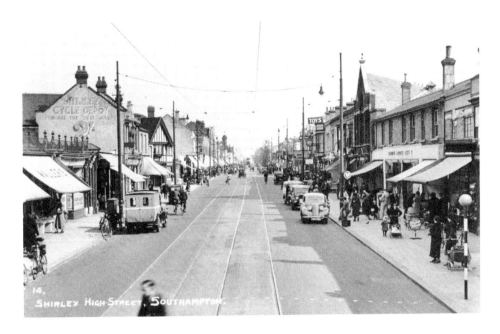

## Shirley High Street *c.* 1938

A busy suburban shopping centre, a view typical of the immediate pre-Second World War period, it was impossible to exactly replicate this as it was taken from the top deck of a tram. The mock-Tudor 'Windsor Castle' has a long history, though this building dates from the 1930s. In 1861, it sold Ashley's of Ealing Beer, then Scrases of Southampton beer, next Strongs of Romsey and finally Whitbread's in 1969. On a different note the tower of St Boniface church is visible in the distance.

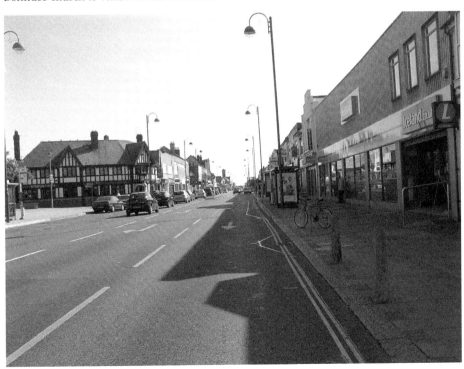

Shirley Road *c.* 1972

The Rialto was a purpose-built cinema with seating for 928 people at the rear of buildings facing the main road, which opened on 9 January 1922. 325 Shirley Road was the entrance foyer leading to the auditorium. It was independently owned until bought by the Odeon circuit in 1937, closure coming in November 1960. The entrance became a shop and the main building a furniture store. In recent years development of the site has an Italian restaurant on the main road and flats replacing the auditorium.

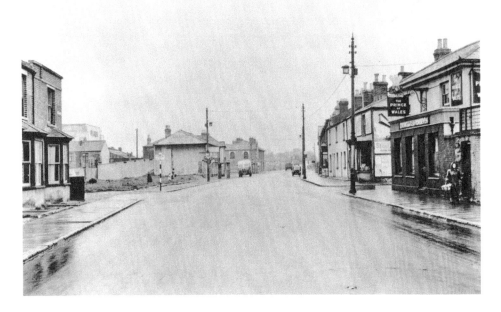

### Northam Road c. 1946

Northam Road after the war, bomb damage allows us to glimpse the Plaza Cinema, a magnificent building of 1932 seating 2,100 and a Compton organ but built in the wrong place, closing in 1957. For a while the building was used by Southern Television and its successors. Now they have left and the site cleaned for redevelopment. The Prince of Wales public house remains, and the building line on the right shows the route to the old bridge, which was somewhat narrow and replaced in 1955.

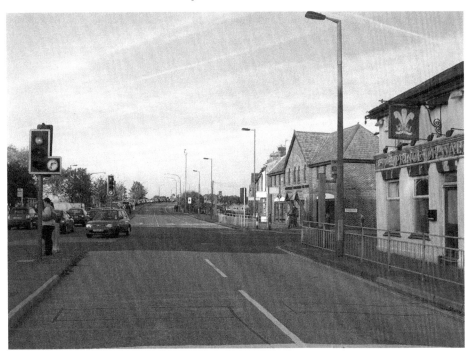

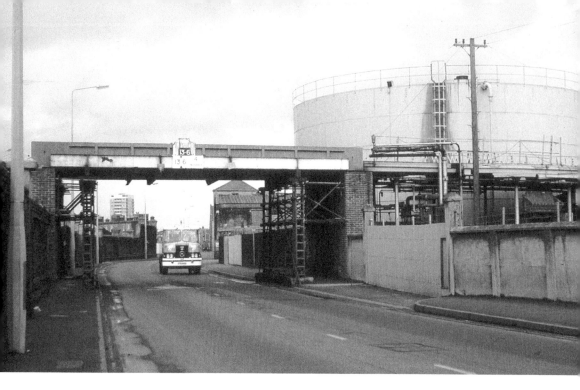

**Marine Parade 1973**

With the advent of North Sea gas, all gas works became redundant and, even though it had converted from coal to using by-products sourced from Fawley refinery, Southampton was no exception. The bridge had been used to bring coal from wharfs on the Itchen to the works. When Southampton Football Club, then in the Premier League, were looking for a larger stadium they were forced to use this 'brown field' site rather than their preferred location on the edge of town.

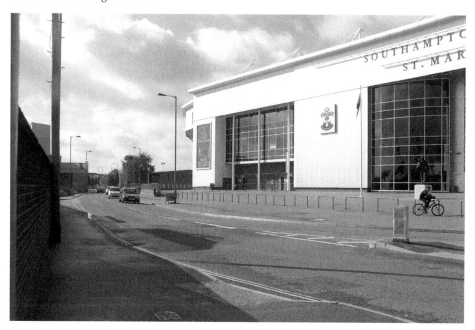

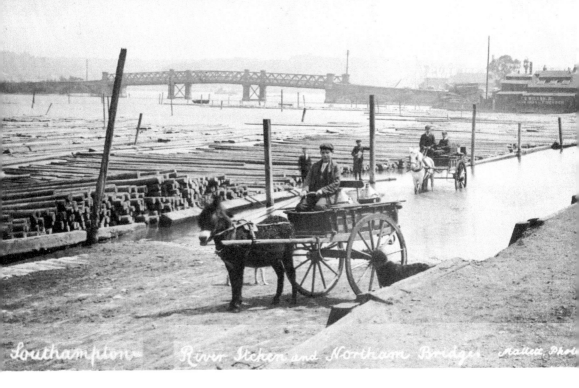

*Southampton — River Itchen and Northam Bridges*    Mallett Phot

### Northam Bridge *c.* 1900

One of those 'smile please for the camera' photographs so common in early views, but they still convey so much atmosphere, the young looking lad with pony and two wheeled cart — is that milk he has? — and the horse and cart making its way through flooded foreshore. The timber ponds and the iron bridge can be seen in the background. When compared to the modern and rather uninspired image, one has to wonder, 'is it my photography or just that times change?'

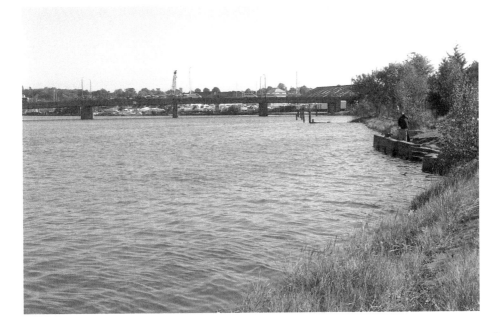

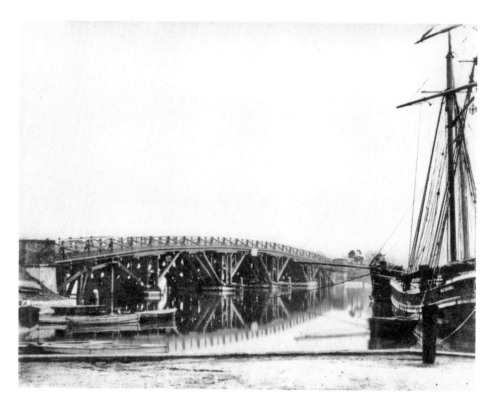

**Northam Bridge** *c.* 1880

The original wooden bridge erected in 1797 was replaced by an iron bridge in 1889, which in turn was superseded by the current concrete structure in 1954. Originally owned by a private company it remained a toll bridge until acquired by the corporation in 1929. This enabled the town's buses to provide a link between the eastern suburbs and the town centre. The present bridge was built just north of the previous bridges to allow for dual carriageway not only on the bridge itself but also the approaches.

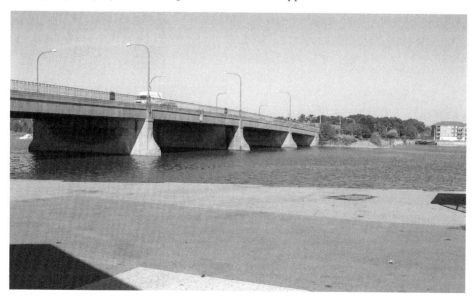

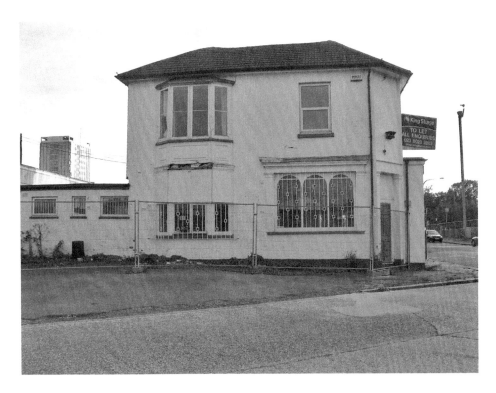

**Northam Road** *c.* 1910

Northam baths was run by the Corporation from *c.* 1900-30. Nowadays, the Coalporters Rowing Club building is on the site. The clock was opposite the Northam Bridge Toll House and gate, with Northam Road on the right past the Ship Inn, which opened in the 1830s. Over the years it has sold Barlows, Brickwoods, and Whitbread ales. Unfortunately, when the television studios over the road closed the Ship Inn followed.

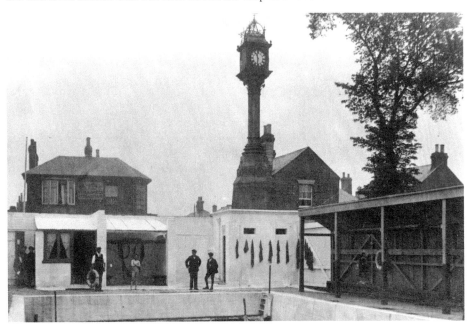

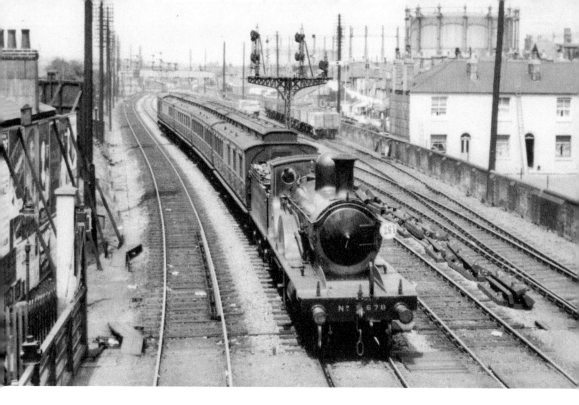

### Chapel Road c. 1925

Chapel Road level crossing once had its own signal box and gates with perhaps 100 or so movements per day with passenger, goods, and docks traffic. The locomotive is an Adams 4-4-0 T6 Class on a train of Great Western Railway coaches heading for Southampton Terminus probably from Cheltenham. Note the gasholders now replaced by the new St Mary's football ground for the Saints.

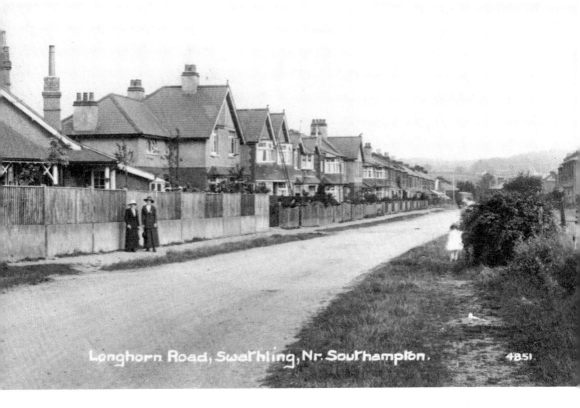

Langhorn Road, Swathling, Nr. Southampton.    4851.

**Langhorn Road** *c.* 1905

When this card was published Langhorn Road was outside the borough boundary, and later it was for a while the boundary. It is now a busy link road, with, just visible on the left, the most awkward traffic island in town. The bungalow has for many years been a retail outlet of assorted descriptions but otherwise most of the original buildings remain.

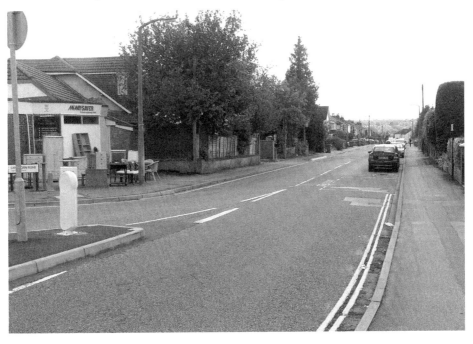

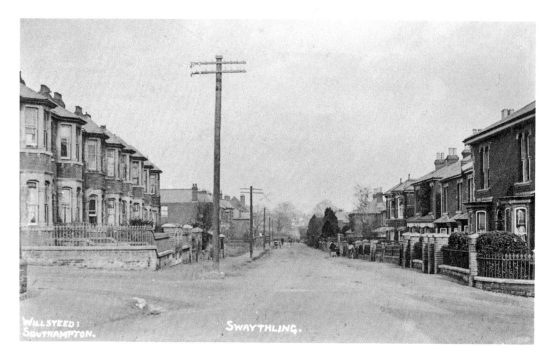

**Swaythling High Road** *c.* 1905
Looking north from the other end of Langhorn Road, the left-hand side remains much the same, but on the right the club buildings have migrated from the other side of Woodmill Lane and the trees mark the position of the Savoy cinema (1938-1959), which originally had 1,505 seats, later was reduced to 1,032. Note the line of telephone poles, now replaced by streetlights and telephone distribution poles.

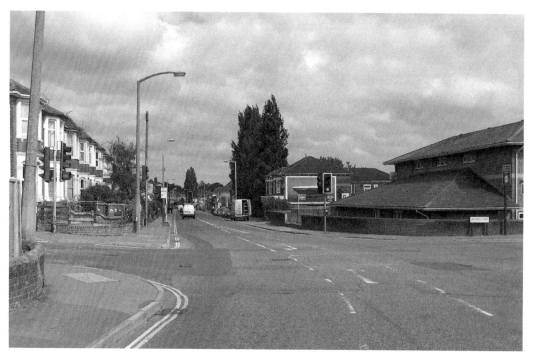

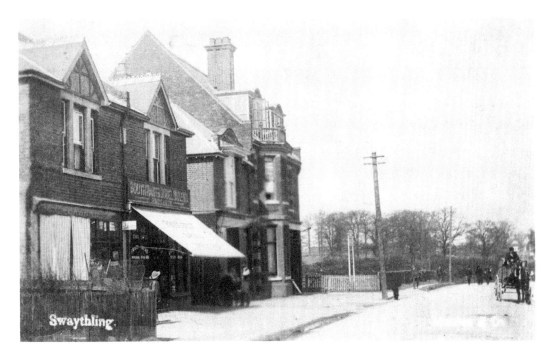

**Swaythling High Road c. 1905**

The shopping centre of Swaythling, looking somewhat rural. Note the telegraph poles and the absence of street lighting. In the current view the bottom of Burgess Road with 1930s council houses is visible, as is the continental influence with outdoor dining facilities, though with our weather and the adjacent traffic I wonder how much use is made of it.

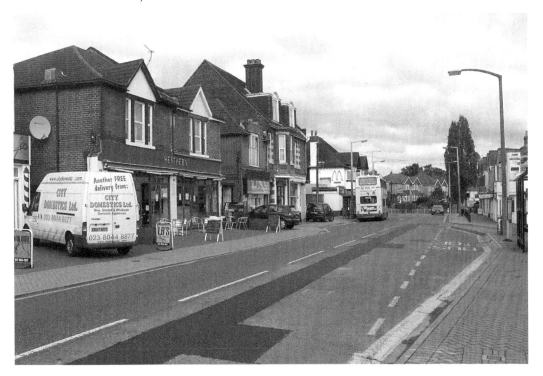

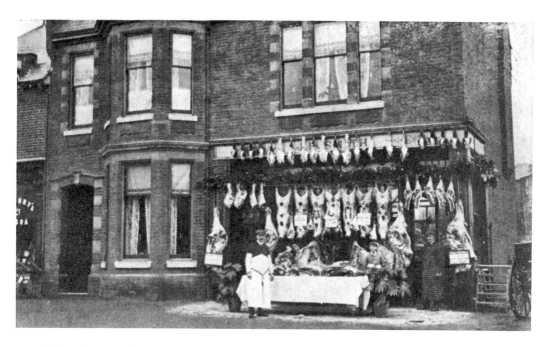

## Swaythling High Road *c.* 1910

Detail of two buildings opposite. Featured on this advertising card are the premises of Mr. J. H. Smith, purveyor of High Road, Swaythling, and in this posed photo it is probable that all of his stock is on display, with staff and a delivery cart just visible — a sight not seen today. The butchers survived until the 1970s, and the building has since seen several changes of use.

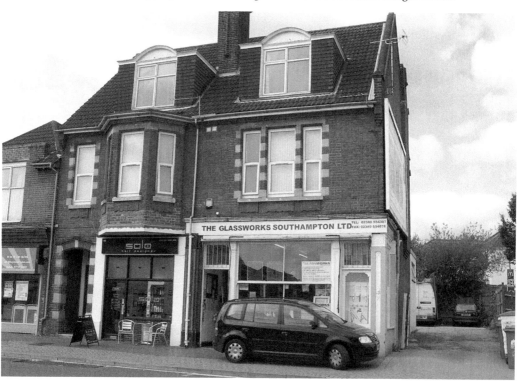

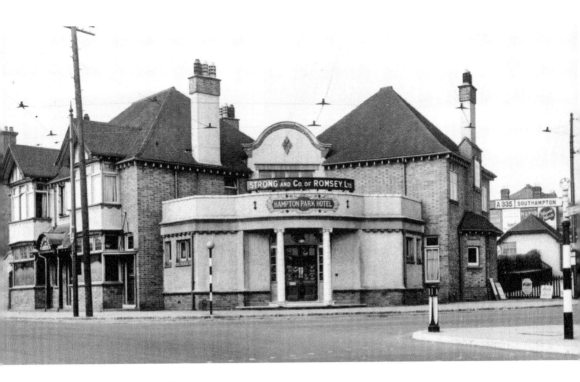

**Swaythling High Road** *c. 1936*

It is May 1936 and Reg Mawes will be pleased to see you at the newly refurbished Hampton Park Hotel, at that time serving Strong of Romsey beer. The pub had opened in 1924 to cater for the nearby estates then being built. In 1989, after various incidents, it was closed. In 1991, after refurbishment it re-opened, now named The Black Cat. However, this was not to last and for the last few years it has been a McDonalds.

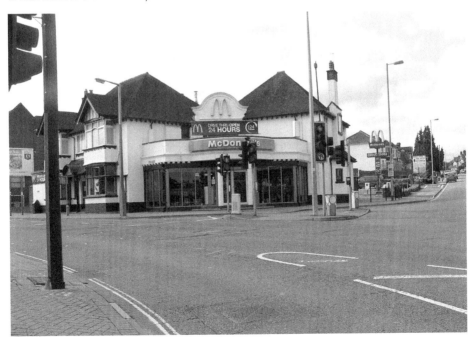

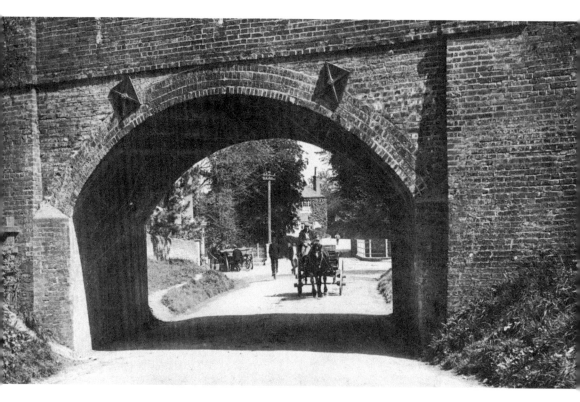

### Stoneham Way *c.* 1910

The notorious Swaythling Railway Arch, once a peaceful scene with the Fleming Arms just visible on the left and the bridge over Monk's Brook. Though not obvious perhaps in my photo, the traffic is very busy, with the motorway link road across the picture. This bridge has been responsible for the conversion of several double-decker buses into single-deckers and also lorries losing their cargo, and it is to be hoped that the warning signage will prove effective in the future.

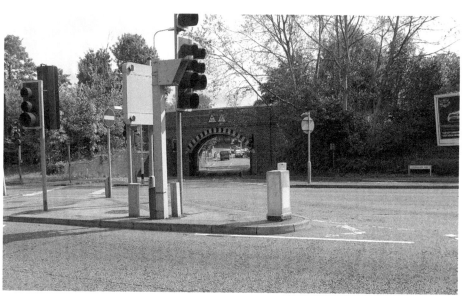

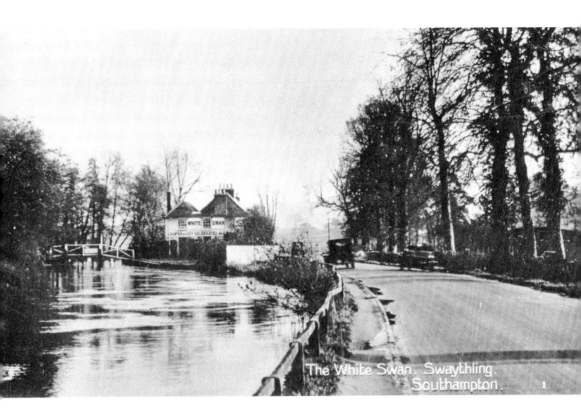

**Mansbridge Road c. 1925**

The White Swan (originally Middleton Arms *c.* 1810, then Swan Inn 1830, finally White Swan 1870) with the A27 main road. Note the bridge over the river Itchen that led to its Riverside Gardens. In the 1960s, it began to serve ploughmen's lunches and the buildings were extended. However, when the A27 was relocated some 100 yards south in 1970 trade declined, but refurbishment in 1988, which stressed the restaurant side, restored its popularity and, though occasionally being flooded, it maintains its popularity.

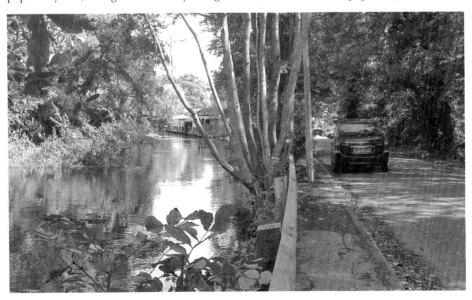

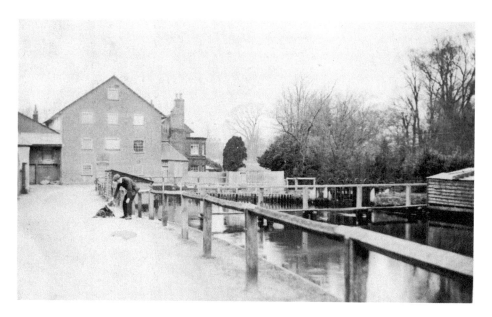

## Woodmill Lane c. 1905

There has been a mill on this site for centuries, though this building only dates from 1820, the previous structure having burnt down. This mill, however, has gone down in history as being the factory that manufactured the wood blocks and pumps for the ships of Nelson's Navy from 1780 until 1810, by when the navy had built their own facilities at Portsmouth dockyard. Every morning seagulls take residence — usually as ridge decoration, but if it gets too crowded then any old bit of roof will do.

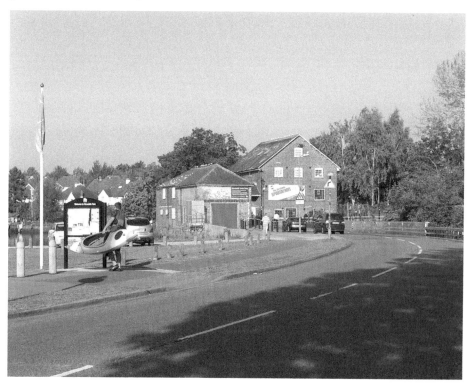

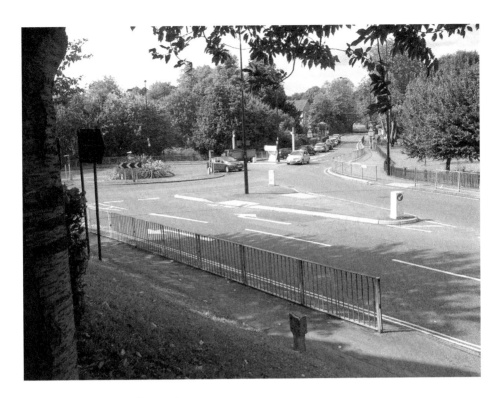

Swaythling High Road c. 1938
The railway arch can just be discerned in the distance, and in the middle is a rear view of The Grange, which, in 1908, became the Southampton Home of Recovery until this function was taken over by Fred Woolley House after the First World War. Next is an antique shop, and the view is from the terrace of the then newly erected row of shops and dwellings. Unfortunately, owing to a cluster of bushes I could not replicate the precise position.

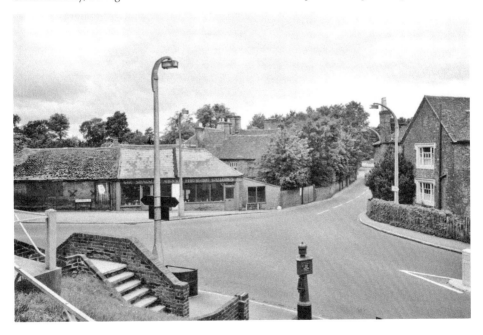

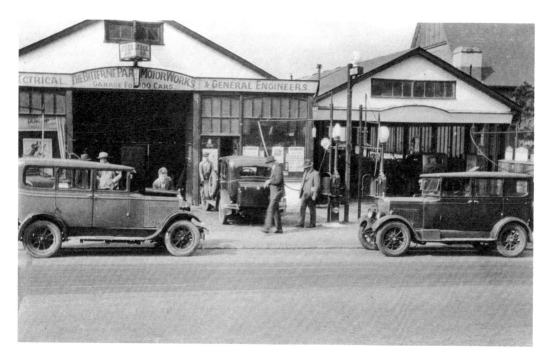

**Cobden Avenue c. 1930**

The Bitterne Park Motor Works with a single tram track in the road outside. A wonderful period photo, which includes a corner of the now United Reform church. Note the selling point of 'free air', a garage remained on this site, which a few years ago added a shop to petrol sales. Finally, they have given up the petrol and become a mini store, which is, unfortunately, not in the best of locations for easy traffic access.

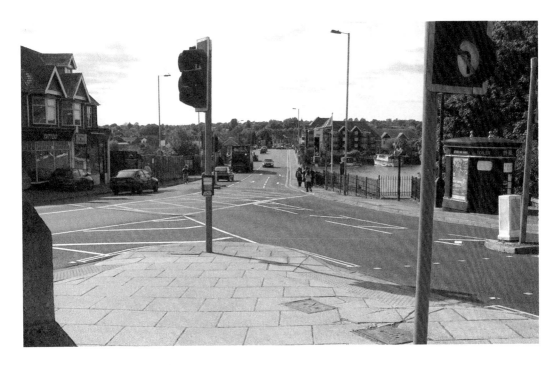

### Cobden Bridge c. 1905

This bridge has an unusual origin: it was built in 1883 and donated to the town by the National Liberal Land Co. who were developing a large housing estate at Bitterne Park, which, at this stage being on the east of the river Itchen, was outside the town boundary. Eventually, in 1895, incorporation into Southampton followed, and this was the first invasion east of the river Itchen until the 1920s. The original bridge was replaced in 1928 by the current structure, and tram track was first laid in 1902 with the service closing in 1948.

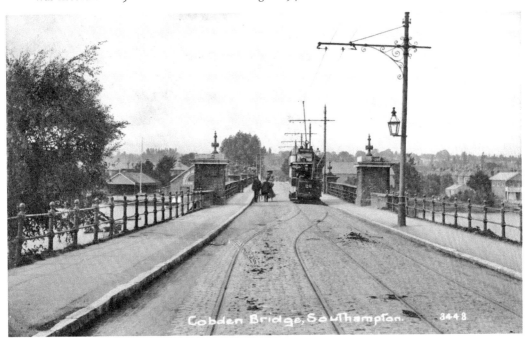

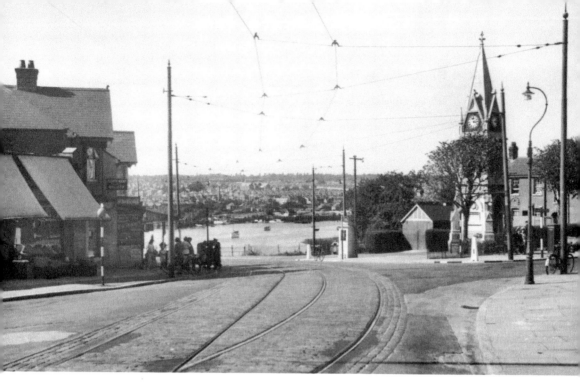

**Cobden Avenue *c.* 1937**

Not a lot has changed, the tram tracks and their overhead wires have gone, and the trees have grown obstructing one's view of the river Itchen. Prominent on the right is the clock tower, which migrated from New Road/Above Bar in 1935, and it originally had a drinking trough for horses and dogs on the north and south sides with a drinking fountain for the two-legged on the west. I think this tower is leaning to the west, which can just be discerned in the photo (Southampton's Pisa).

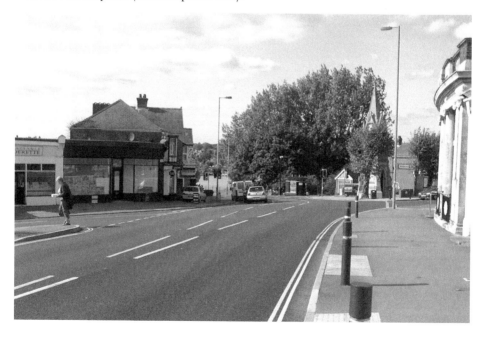

Chessel Avenue *c.* 1910
This was one of the drives
for Chessel House. Note
the pillars, which have
been moved to enhance
the extension of a much-
altered Magellon Lodge.
The estate was broken up
for housing after the First
World War. Being described
as Southampton's Garden
Suburb, Chessel House itself
was demolished in the mid-
1920s.

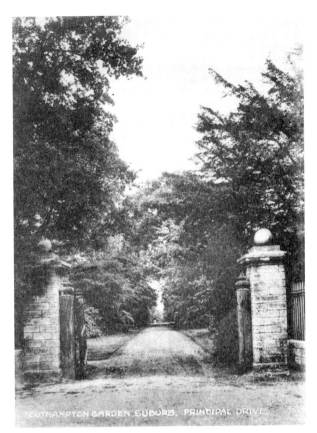

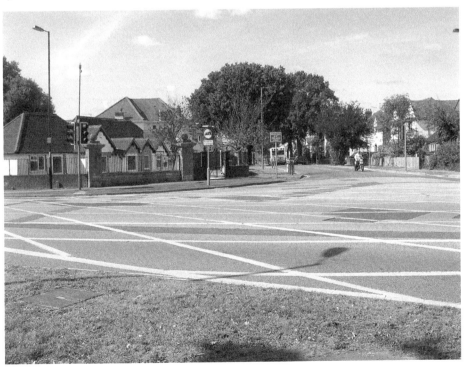

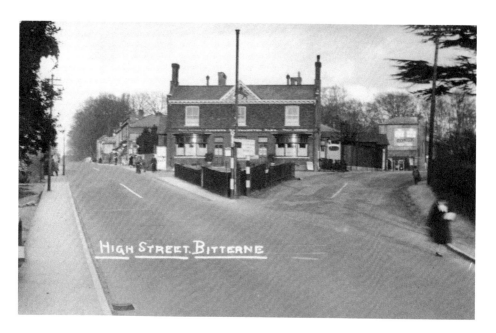

**Bitterne Precinct *c.* 1930**

The Red Lion, which replaced an earlier building in 1860, though with some later alterations, stands the junction of the main roads to West End and Burlsedon, which in later years became something of a bottleneck, so it was with relief all round that traffic was diverted to the north and the road through Bitterne shopping centre pedestrianised.

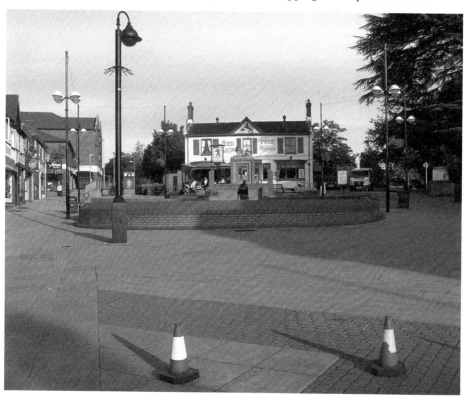

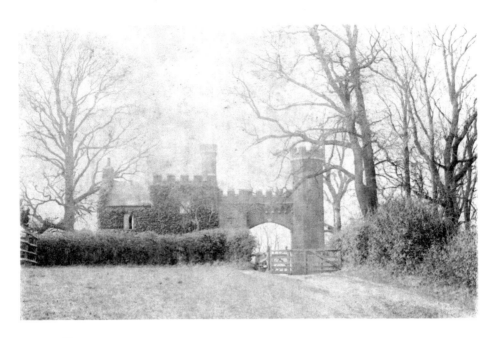

**Witts Hill** *c.* 1903

Midanbury Castle, so called for obvious reasons, was actually the gatehouse for Midanbury House some way to the rear. The estate was purchased in 1927 for development by the builder T. Clark & Son and the house was demolished soon after, but the gatehouse survived into the mid-1930s, being replaced by the pub before the Second World War. It is still open after some problems and, remarkably, has not been inflicted with a fancy name change.

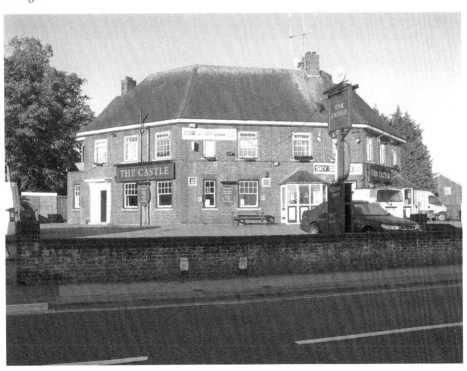

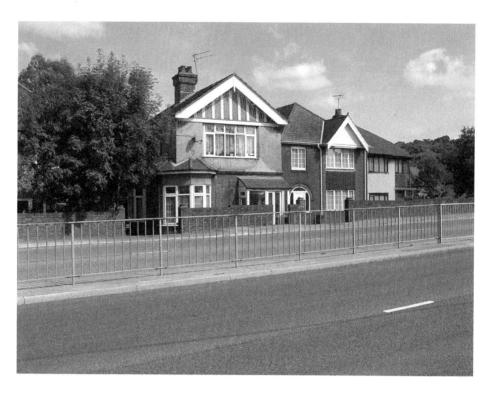

### Bitterne Road *c.* 1910

The Tollhouse on Lances Hill, which replaced an earlier wooden hut in the early 1920s, was once in isolation —nowadays, blink and you'd miss it. Its elongated porch has gone, but there is no doubt it is the same building. The company, which also collected tolls at Northam Bridge, was bought by Southampton Corporation and freed on 16 May 1929 with much jubilation and ceremony as this allowed buses to at last link the main areas to the east of the Itchen with Southampton proper.

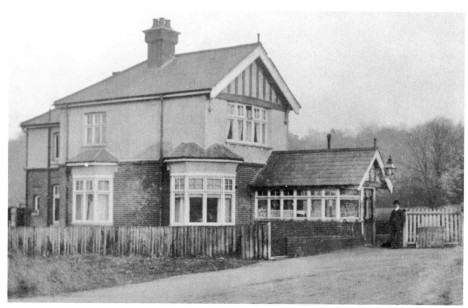

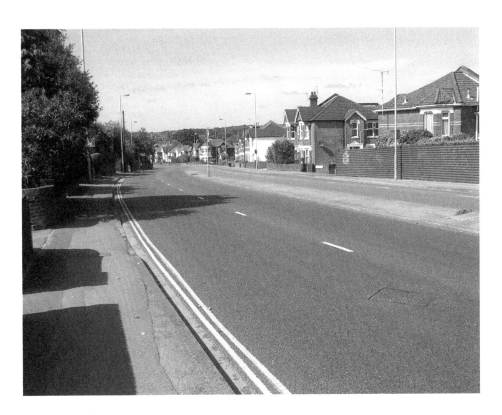

**Bitterne Road** *c.* 1930

Down the hill from the tollhouse, this view includes the thatched Chessel Lodge, left, and the shop blind of Vincent Lane, a grocer, right, both of which are now gone. Nowadays, we have a busy (despite my picture) dual carriageway governed by a linked (so the motorist is told) traffic light system into and out of Southampton.

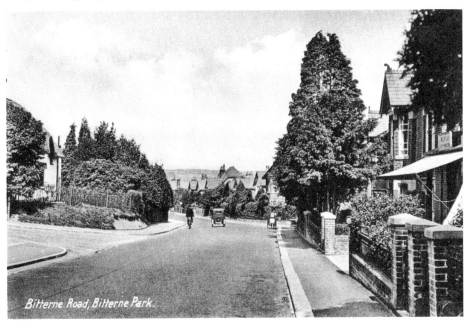

*Bitterne Road, Bitterne Park.*

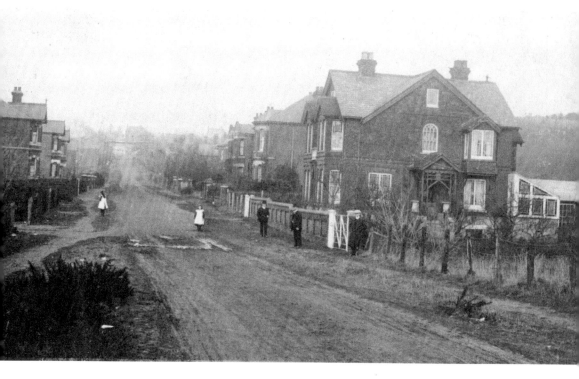

**Cobbett Road *c.* 1905**

A fine residential road, still being developed, and with the sprinkling of human interest obligatory with many early photographers. Apart from the first on the right, all the visible buildings remain, though further along blocks of flats are now appearing. In the foreground a gyratory system eases the traffic flow at the Bullar Road junction with Bittene Road.

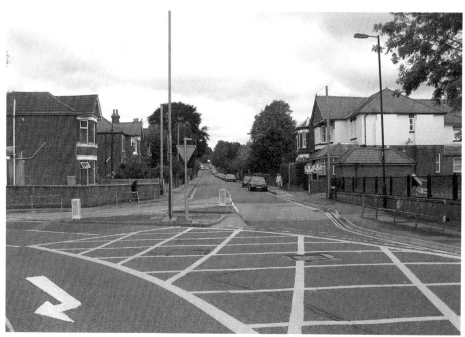

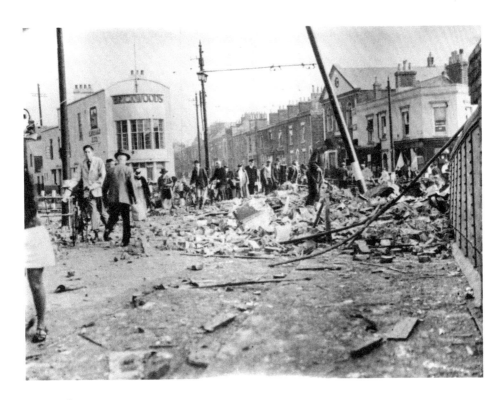

### St Mary's Street 1940

The morning after bomb damage at Six Dials with people picking their way through the rubble to get to their work place — if, indeed, that had survived. Note the bridge, which is over the main railway line probably blocked by rubble from nearby houses. Most of the buildings in the original have been removed to allow for a multi-lane road junction, the other side of the trees bypassing a stretch of Northam Road.

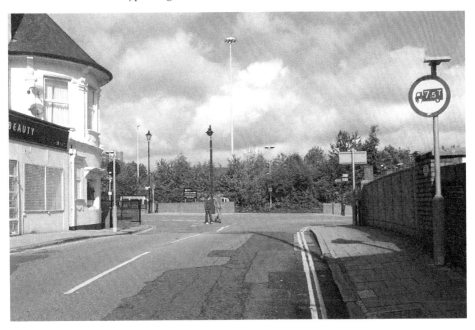

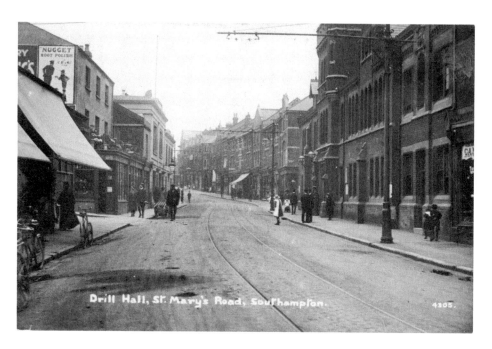

**St Mary's Road _c._ 1905**

The imposing frontage of St Mary's Drill Hall — erected in 1869 and used as a sports hall from 1976 — which received major refurbishment in 2006. This has ensured its survival along with its surrounding buildings, but all has changed in the distance and on the left. Though not a main thoroughfare because of road alterations, it remains busy with traffic for the old South Hants Hospital, which lies behind on the right-hand side.

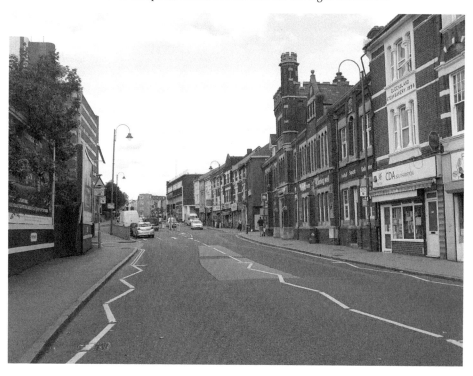

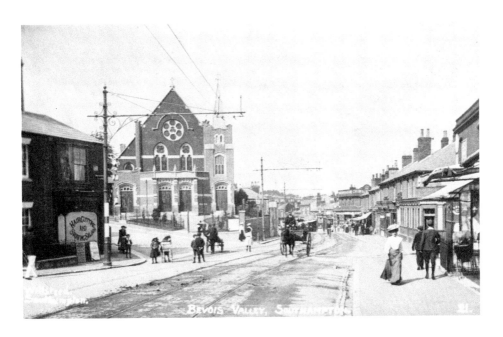

## Onslow Road *c.* 1908

A busy animated scene on a summer afternoon (the sun always shone in those days) with prominence given to the Bevois Town Methodist Chapel. In the modern view the shops on the right are now a car sales lot, and there are changes in the distance on the left. The barbers shop has reverted to a private dwelling, but most of all the chapel, having been made redundant, is now a Sikh Temple (Gurdwara Nanaksar) with suitable modifications.

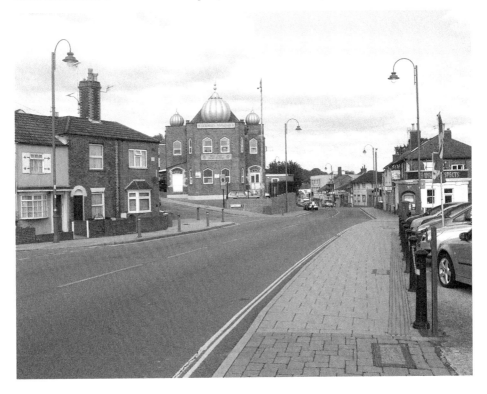

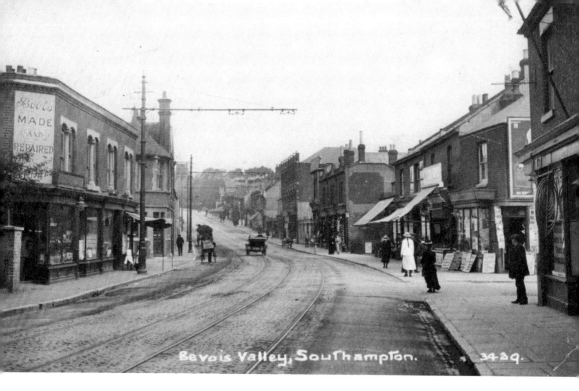

### Bevois Valley c. 1905

A little further down the valley you can no longer get your boots made or repaired, neither can you have a drink at the Mount Hotel, which closed in 1958. Once owned by Coopers Brewery, it was a Watney's house at the end. Some buildings are recognisable on the right, but one wonders for how much longer.

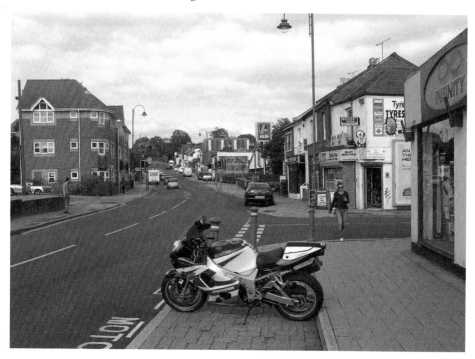

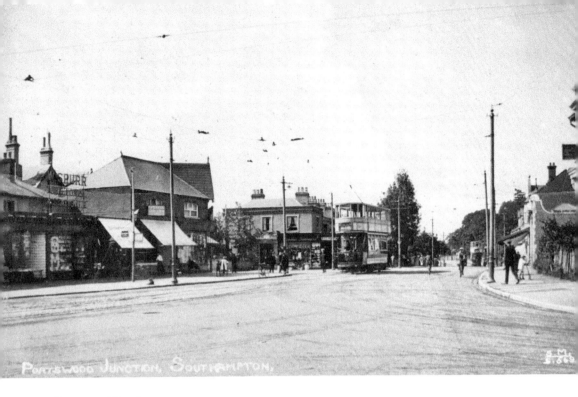

**Portswood Road** *c.* 1920

Portswood (Tram) Junction, looking in this view surprisingly rural with unmade up roads. Two trams are in view, both with square-covered tops of the type that could not go through the Bargate, so they must be on the service to the docks via St Mary's. Otherwise all the buildings seen are still there.

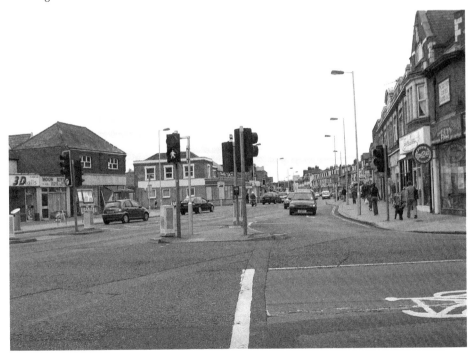

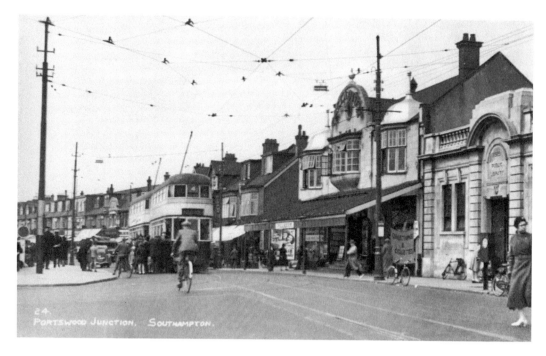

### Portswood Road *c.* 1938

Portswood Junction from a slightly different angle. We have moved on to just before the Second World War and the rural aspect is long gone, the road is tarmaced and the trams are of the domed type that could pass under the Bargate. The public library opened in 1915 is in evidence and next to it is the Palladium Cinema, opened in February 1913, which succumbed to the competition from television in 1958, and subsequently became a supermarket. Apart from the street furniture, very little has changed.

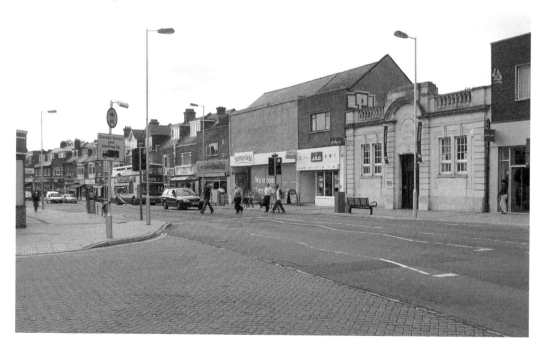

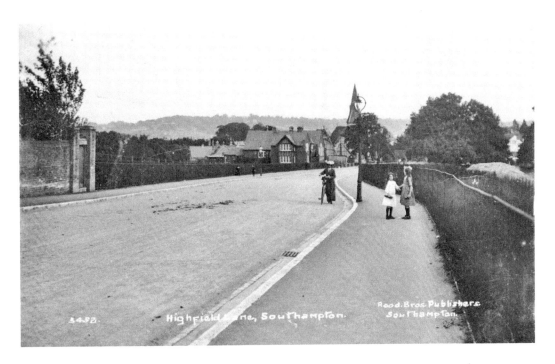

### Highfield Lane *c.* 1905
Looking towards Portswood, with only two children and a lady with a bike for animation. In the background is Christ Church with its institute and hall, also the then undeveloped hills above Bitterne Park. In the modern view, the church and associated building are still there, and hidden behind the hedges on either side are housing estates designed by Herbert Collins, an architect responsible for many Southampton buildings, mainly between the wars.

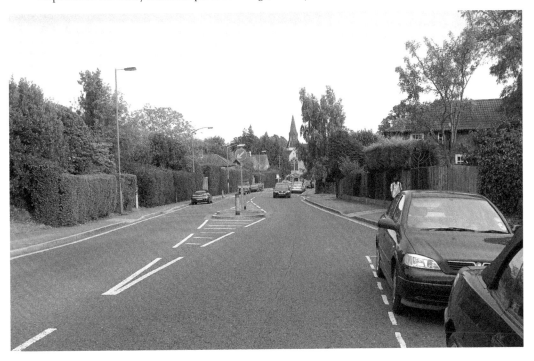

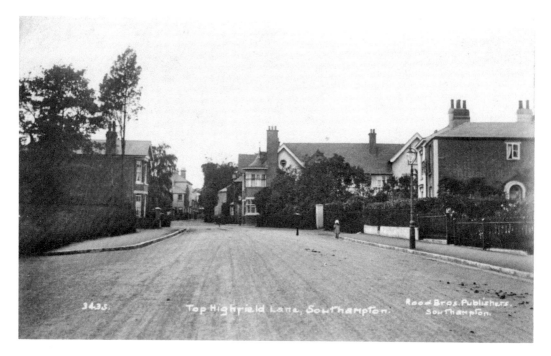

**Highfield Lane *c.* 1905**
Looking towards Bassett, the cluster of houses is part of Highfield Village. The road narrowed quite alarmingly, so most of the houses have now gone in order to improve it, though there is still a pinch point alongside the white building (once shops) in the middle distance.

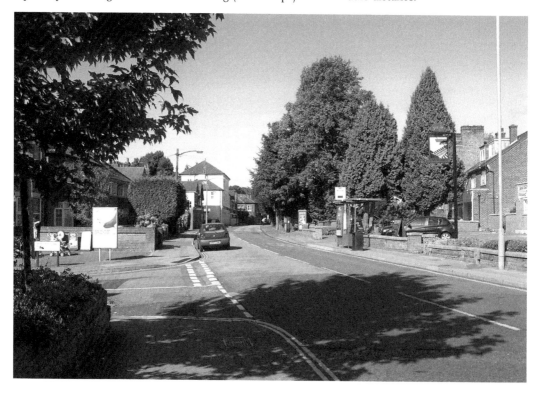

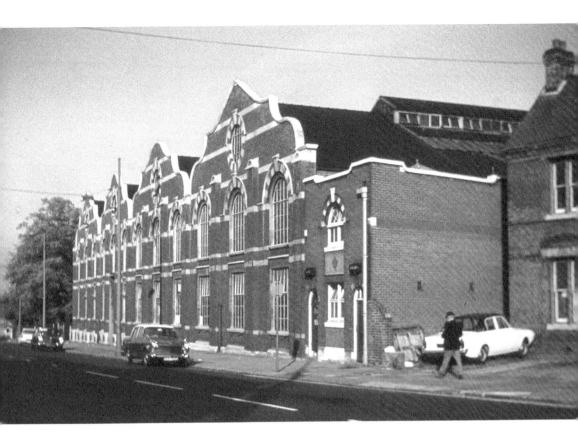

**Portwood Road *c.* 1973**
The Corporation Tramway Works where for some thirty-five years Southampton trams were built and repaired, followed in due course by maintenance of the bus fleet. However, rearrangement of the St Denys Road junction meant demolition with new buildings further back on the site and the area seen being used for open-air parking. All this is due to change, the bus depot having been sold to allow for a proposed supermarket, housing, and a health centre to be built.

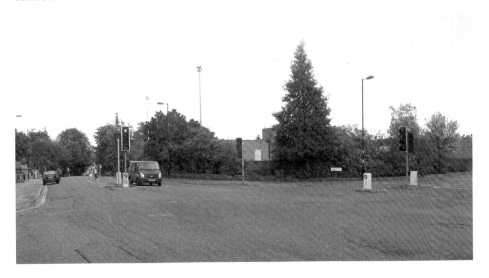

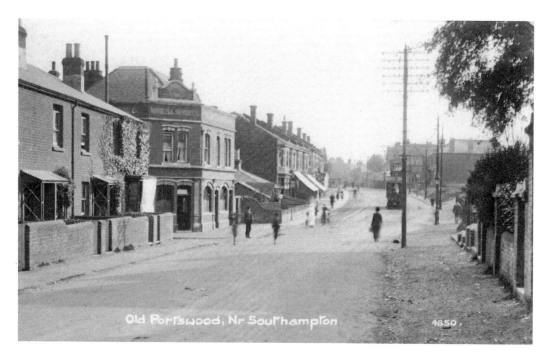

## Portswood Road *c.* 1908

The Brook Inn is all that remains from the period view when the borough boundary ran access from left to right, which accounts for the corporation trams terminating at this point. The Brook has dropped the 'Inn' and changed its character, but the main difference is in the traffic.

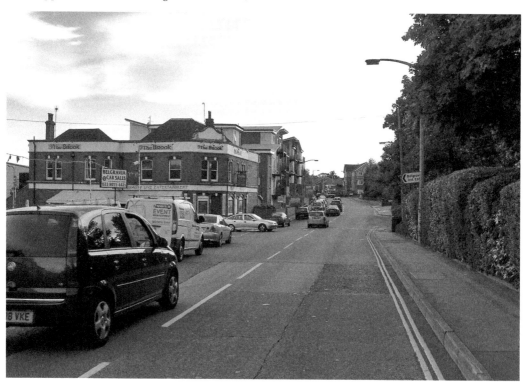

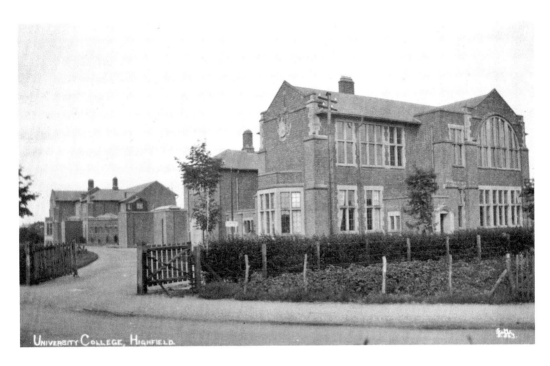

## University Road *c.* 1914

The Hartley College situated in the High Street was short of space and decided to transfer to a green field site at Highfield. By the outbreak of the Second World War, building had progressed to this stage leaving the central library block to be completed in the 1920s. The buildings, as shown with the addition of many temporary huts, became a hospital for the duration of the First World War. Mature trees make a contemporary view difficult.

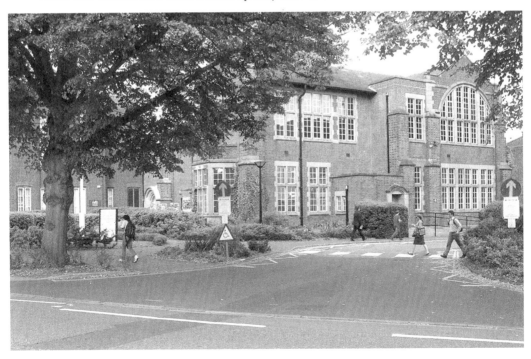

**Orchard Place c. 1880**

This shows some elegant town houses, though even then some were being used as hotels. The three houses in the middle are on the site of the present Briton Street, effectively a new road from post Second World War re-planning. In the modern view the memorial to Major-General Gordon, who resided in Rockstone Place, was erected in 1885. Trees cover most of the background, but Briton Street is just visible between the trees.

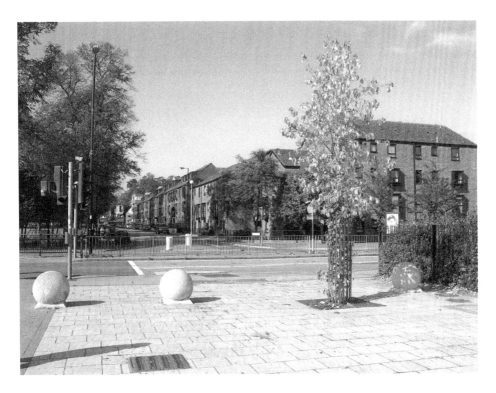

**South Front *c.* 1905**

An interesting collection of buildings, including a Methodist chapel viewed from Kingsland Square, bombing during the war destroyed virtually the entire row. One survivor was the George Burns public house the other side of the church. The entire block is now post war development. The new inner ring road runs through in the front of the scene from right to left.

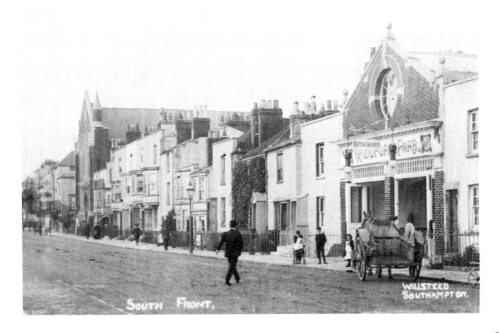

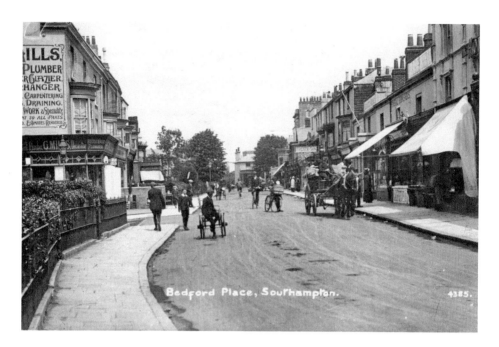

### Bedford Place *c.* 1910

Bedford Place remains as a shopping centre retaining virtually all of its period buildings with their many attractive features, including the shoe manufacturer and repairer shop of French & Son, which still serves its bespoke cliental. The only change is the white house in the distance removed to straighten up the road, replaced by St Anne's College, though there is still a kink in the road to mark the spot.

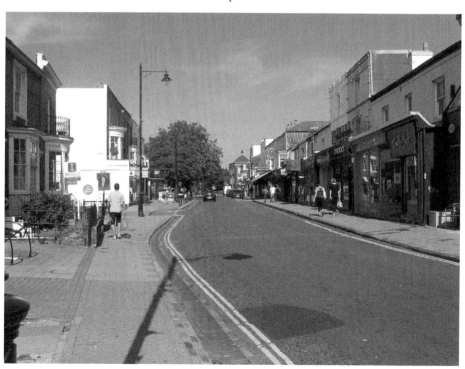

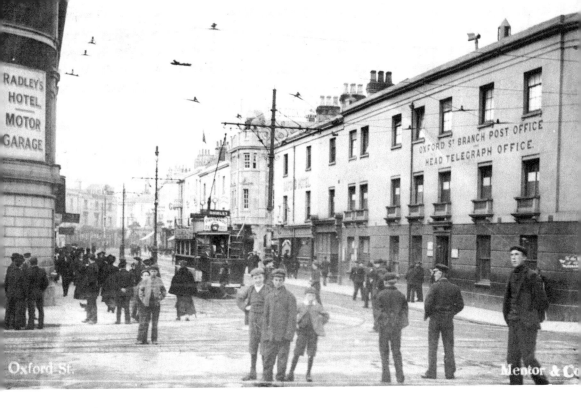

### Oxford Street *c.* 1904

Once again a shot that captures the time with what appears to be a young lad hitching a ride on the tram fender, unfortunately for tram enthusiasts obscuring the number. The undistinguished buildings on the right became a pub and an office block with a Marine Outfitters on the ground floor, however this shop, amongst others in the area, have now all become restaurants.

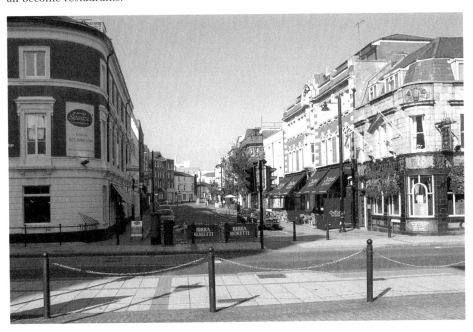

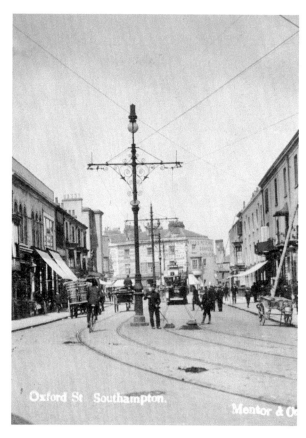

**Oxford Street *c.* 1905**
Round the bend from the previous picture, the right-hand side remains the same but on the left and in the distance bomb damage and redevelopment have altered the scene completely. Of note is the decoration on the tram wire support poles and also the amount of advertising on the building at the end of the road.

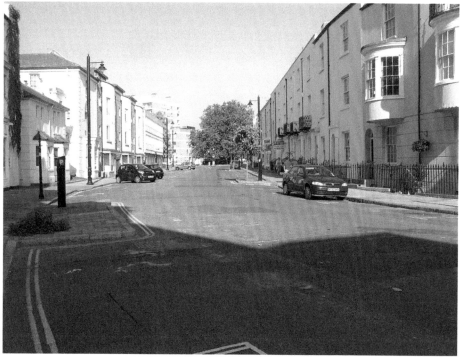

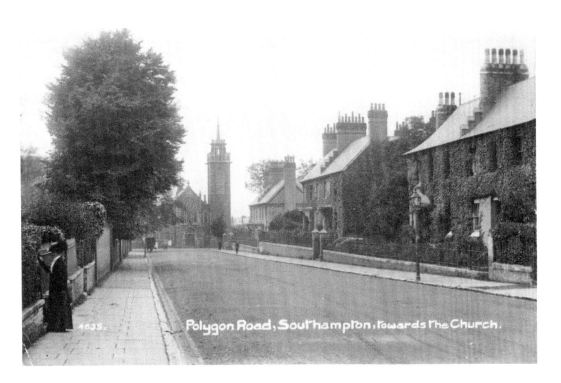

**Henstead Road c. 1913**

Polygon Road has been renamed Henstead Road but the now Central Baptist Church, erected in 1910, is still looking down the road. On the right are the Thorners Charity buildings, which were damaged by bombing during the war and replaced by a very functional modern structure.

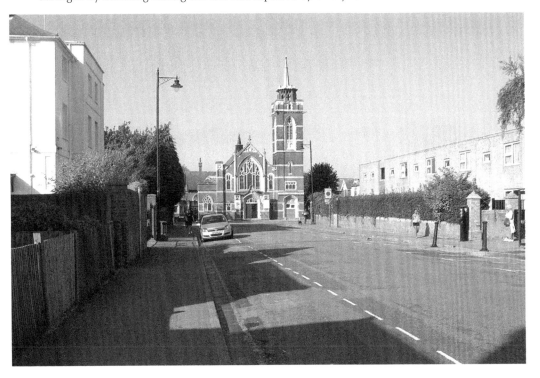

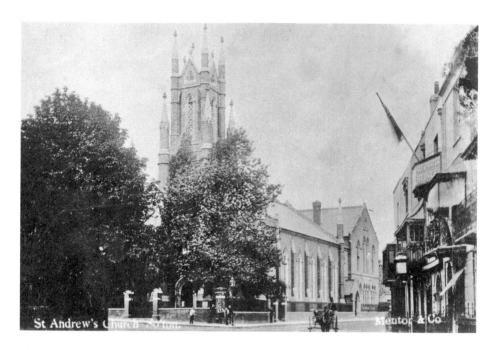

**Charlotte Place** *c.* 1903

St Andrew's Presbyterian church, built 1852/3, latterly a United Presbyterian and Congregational church, with its two rows of four pinnacles on the tower, was originally in a quiet backwater. However, it became redundant and was demolished in 1998 to be replaced by an office block. This is now the main road north from the town centre and a junction with the inner ring road is made with a large roundabout on the right containing a hotel and flats on the inside.

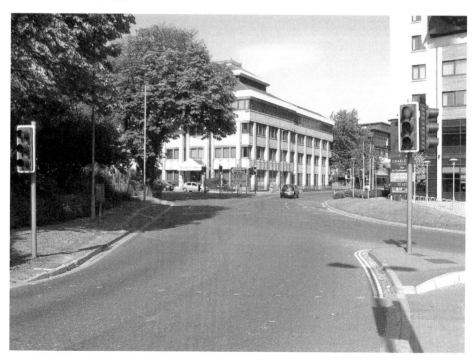

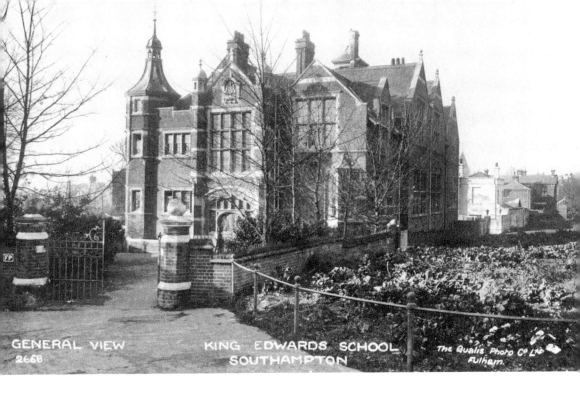

GENERAL VIEW
2668

KING EDWARDS SCHOOL
SOUTHAMPTON

The Qualis Photo Co Ltd
Fulham.

**Havelock Road c. 1910**

King Edward VI School obviously has a long history being founded in 1564 with premises in Winkle Street, then Bugle Street (1696-1896), and next were these buildings (1896-1938) and finally to new buildings in Hill Lane. When they moved just before the Second World War the buildings remained to become, with the addition of temporary huts at the rear, the local NAAFI Club for the duration of the war and a while afterwards. Demolition eventually followed and the site remained vacant until the BBC buildings were erected.

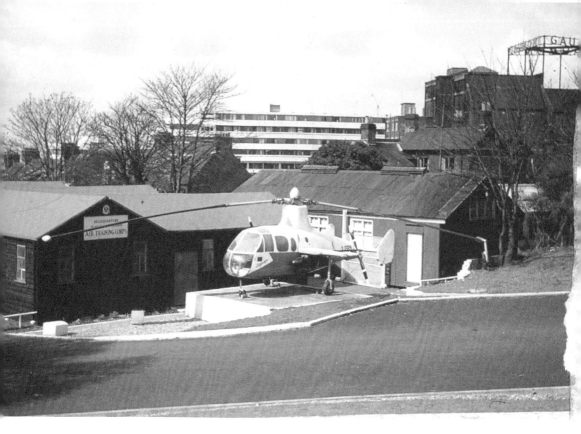

**Havelock Road *c.* 1973**

This view shows the buildings using a bombsite behind the NAAFI club, which at this stage are in use by 424 Squadron ATC with, in a prominent position, the Fairey Jet Gyrodyne, an experimental helicopter first flying in this form in 1954. All ATC Squadrons can have withdrawn aircraft to aid in instruction and this aircraft being close to Southampton's first Spitfire Museum (now Solent Sky) attracted a lot attention. It is now in the Museum of Berkshire Aviation and the ATC and Solent Sky are near the Itchen Bridge.

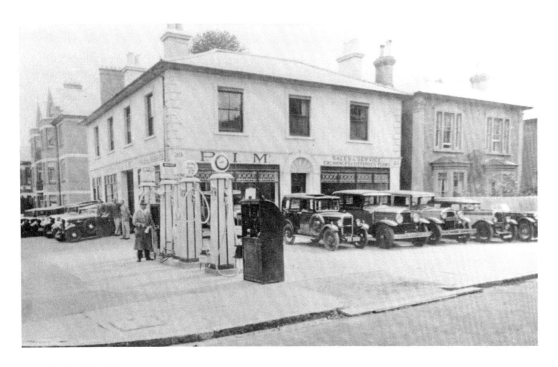

**Lodge Road** *c.* 1930
The corner of Lodge Road and the Inner Avenue at a location known as Stag Gates, the garage was trading as PIM (Portswood Incorporated Motors). Damaged during the war, it reopened as the Stag Gates Service Station but is now Avenue Cars, concentrating on sales and rentals.

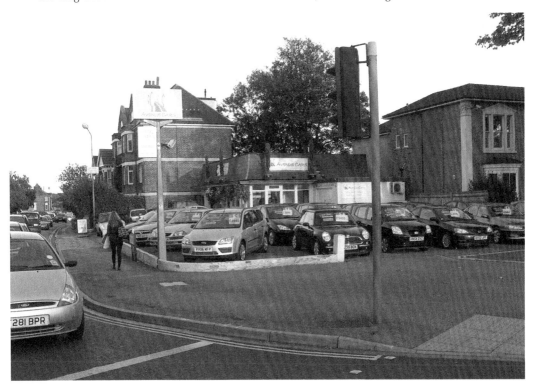

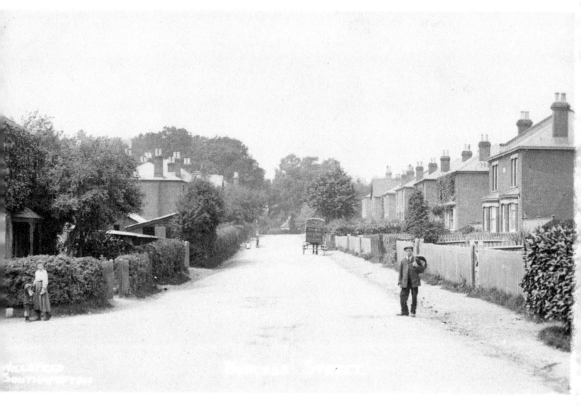

**Burgess Road *c.* 1905**
Known as Burgess Street until the 1920s, the turning on the left is now University Road, this side has succumbed to university expansion over recent years, though the right is comparatively untouched. As part of only two cross town routes north of the city centre, this idyllic scene is lost forever.

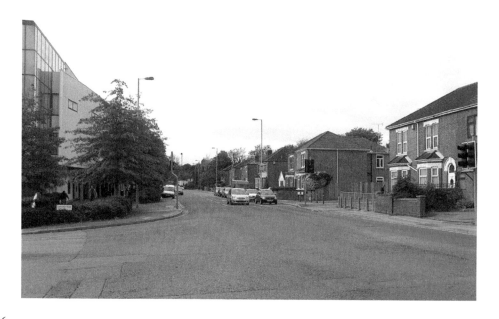